D1124673

CAPTIONING THE ARCHIVES

McSWEENEY'S

SAN FRANCISCO

McSweeney's and colophon are registered trademarks of
McSweeney's, an independent publisher based in San Francisco.

ISBN 978-1-952119-15-6

10 9 8 7 6 5 4 3 2 1

www.mcsweeneys.net

Printed in China

CAPTIONING
THE ARCHIVES

A Conversation in Photographs and Text

PHOTOGRAPHS BY
LESTER SLOAN

TEXT BY
AISHA SABATINI SLOAN

PART OF THE *OF THE DIASPORA* SERIES
edited by ERICA VITAL-LAZARE

McSWEENEY'S
SAN FRANCISCO

For Lilli and Ilona.
And for all the children to come—go tape-record your grandparents.

INTRODUCTION

MY FATHER RAISED me on stories of the uncanny. Once, while he was dozing on a plane, a man tapped him awake and pointed to my father's hand. Where, the man wondered aloud, had he gotten his ring? My father paused. The ring depicted scenes from the Torah. He wasn't Jewish, but the imprinted silver had become as much a part of him as the wrinkles in his knuckle. The man asked again, so my father told him: he got the ring at a little shop in New York. "My father made that ring," the man explained. "There are only three in the world." No matter where my father went, some stranger would catch his eye, chuckle softly, and tell him, "Come with me." When people ask me why I write nonfiction, I think of my father's encounters and wonder: What could be more fascinating than real life?

He was a photojournalist for *Newsweek* from the late '60s to the mid-'90s. Though the generosity extended toward him was a testament to the kindness of the human spirit, his adventures were as often laced with danger. His first assignment for *Newsweek* was documenting the Detroit riots. Years later, my mother turned on the news only to see him dodging bullets during a police shootout involving Patty Hearst. Once, on a trip to Poland, he was faced with nowhere to stay, and the elderly owner of a hotel welcomed him into her own home, as all the rooms were filled. She offered him champagne, and they swapped stories at the kitchen table. After a pause, in a barely perceptible growl, she tried to reassure him that there had been no concentration camps. She offered to pour him more drink, and he grinned his assent, hoping to hide the quiet thrum of his terror.

When he was alone, he was usually filming. Once, while he waited for his food to arrive at a restaurant in Paris, he began idly filming a Parisian woman as she fed a hidden dog, whose tiny head popped up from her lap under the table. She realized that the red light of his camcorder was on and that the lens was aimed directly at her, so she began to pick her nose. It turned out she was the sister of a French director, Jean-Jacques Beineix, so this period of my father's life has become blurred in my mind with surreal scenes from the film *Diva*: cameras swinging as my father rides a motorcycle down flights of stairs into the Paris Métro, cascading at full speed through a tunnel of glossy red tile.

When he was home, I would sometimes wake to find him chanting the Lotus Sutra in a cloud of incense smoke in our living room. In a language I could not understand, he requested transformation. When we took him to the Bradley International Terminal at LAX so that he could fly to Mexico City or Berlin, it seemed as though he were stepping through a lava lamp or a screen of static, preparing to shape-shift. When he tells stories from that time, it feels like we are approaching that threshold together.

There are boxes and boxes of photographs in a room upstairs. Sometimes I'll pick up a sheet of negatives and ask him, "Who's that?" Much of the time, I've already heard the story. But sometimes it's something new.

—AISHA SABATINI SLOAN

THE ARCHIVES

The following captions are transcribed conversations between Lester and Aisha. They have been edited for concision. They are offered here in the spirit of an eavesdropped conversation. While this is a work of nonfiction, the stories relayed here are recollections, prone to the vicissitudes of memory over time.

Aisha's questions and prompts to her father appear in bold. Lester's thoughts are set in a lighter typeface. Interspersed through the photos and conversations are essays about Lester's career, written by Aisha, printed on blue pages.

THE GUY WHO PLAYED THE DETECTIVE

———

What do you have to say about the Picasso museum? There are more interesting pictures of the Picasso museum. **But what do you have to say about the museum?** Pumpkin, I remember you saying you don't have to talk about the content of the photograph all the time. It could relate to something else. **So what does it relate to?** An appreciation for history. The architecture of the city. I mean, remember when they built the new museum? It was a backdrop for a movie. **Pompidou?** Was it the Pompidou? What was the movie with the guy from *Forrest Gump*? **Tom Hanks. The Louvre.** The guy who played the detective, when Tom Hanks asked him what he thought about the museum, he said, "A scar on the face of Paris." Because it was modern, it didn't speak to the history of the city; it was totally dropped from space. And to a lot of people, the words in that character's mouth spoke to what a lot of people felt about the place. **So you don't have anything to say about the Picasso museum?**

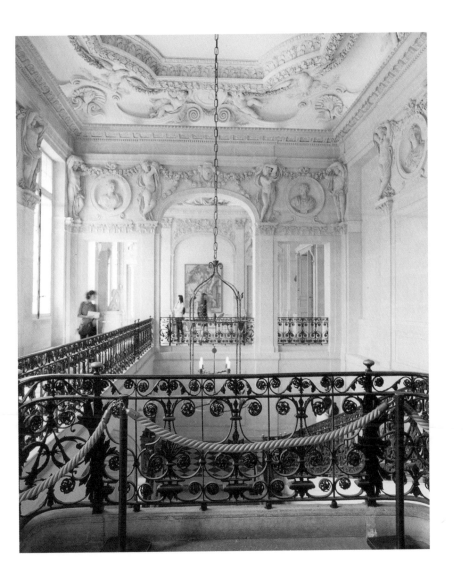

MY FATHER NEVER TALKED ABOUT THE WAR

My mother had never seen the ocean. My father, I found out, had seen the ocean. They were like two kids that day. They took their shoes off and they were walking in the sand. You can't see my father's face, but there was a big smile. This was something they'd never done before. We sat on the beach and had lunch. Stopped off at a favorite restaurant Mom and I had, where they grilled the fish outside, went a couple miles down the road on the beach, parked the car, and found a spot on the beach to eat. This was really an interesting trip. That's the happiest I've ever seen them. Since my father never talked about the war, I never realized he was on the Atlantic Ocean, going to Europe on a supply ship.

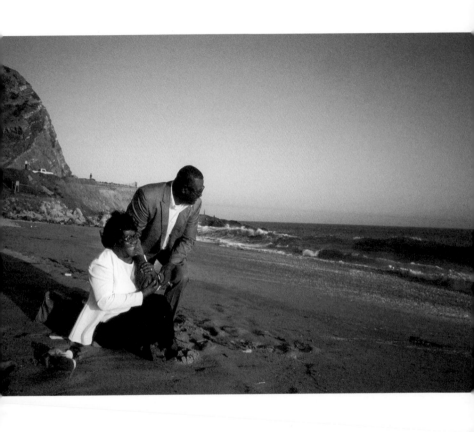

That reminds me of a picture I have of three of us sitting on the steps. And Benrus Brown had just finished reading the funny papers to us, the comic strip. Benrus, myself, and this other little kid, who was sitting in my lap. I think Benrus was the first Rodney in my life. I mean, a friend who was really someone that you respected and envied in a way. A person who could do a little bit of everything well. Somebody with talent that could go anywhere in the world and succeed but who chose a different path. **What was that?** I mean, not to be a baseball player, which he could have been. And, I mean, a professional baseball player. Not to become an artist, which—he had certain artistic skills. **When did you live near 8 Mile?** We moved there—I guess I was five years old, after my father came home from the army. It was a project they built out on 8 Mile. There wasn't a whole lotta housing available for Blacks in the city, excepting a few areas, so they built these projects out there, which was, strangely enough, near a dump, where the dump trucks from the city would spill out the things they picked up. One of the great events that people in the neighborhood did was to go foraging in the dumps, because people threw away some of the most interesting things. Most of the people living in the projects were just getting started having a place to live; some had gotten jobs at factories, some not. My father at the time—I think this was around the time he started working at the Detroit Arsenal, which is a place where they made tanks and what have you, and later at Chrysler, at the plant out there, just out Van Dyke. And my father was also a person who had great skills. My father was a wonderful mathematician. His job originally, or after a while, was that of setting up the machines on the assembly line.

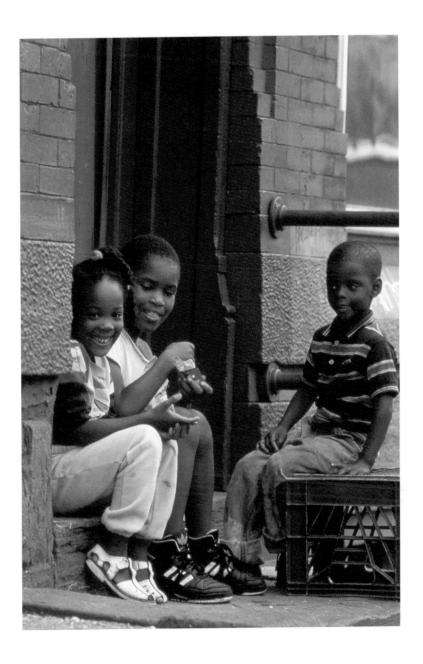

He could have been a foreman, but he didn't aim that high. Just a good job that paid a good living. Didn't want to be a boss, because he enjoyed being one of the fellas. Several times he was promoted, and then he did something silly to be demoted. **On purpose?** He did it—one can only assume he did it on purpose. I don't know if I told you this, but when we discussed me going to college, he said, "Don't go to the plant. If you do that, the first thing you'll do is get yourself a new car, and you're going to buy a house and fix up the basement so your friends can come over to play cards. And you're going to buy fancy furniture and cover it with plastic and you'll think you have arrived. By the time you find out you haven't gone anywhere or done anything, it'll be too late." I realized my father was telling me the story of himself. He said, "Don't tell your mother I told you this, because she'll think I told you the wrong advice," which turned out to be not the case. I've never seen my mother so proud as when she found out I was teaching at a college. And then, you know, meeting the author we got to know in LA. **Maya Angelou?** All these stories sorta connect to some point, like a signpost of where I happened to be at a certain point in my life, and didn't know it at the time, but I found myself. Maya Angelou, after finding out that my mother loved to read—the first thing my mother and father exchanged were books. That was the beginning of their life together. **What did Maya Angelou say?** When I was talking to her I said, "I wanna thank you for introducing me to my mother." She said, "Is your mother here?" And I said, "No, my mother was a caged bird." She sorta found happiness in the simple things of life. She never really stretched herself, excepting when she was part of the Eastern Star Masons. She became quite interested in the teachings. Rodney's wife, Wanda, told me that my mother had spoken at someone's funeral, and Wanda was just amazed; she said, "I never knew that lady was so well-read and so smart."

BALLET LESSONS

———

Hoop dreams. You know where this picture was taken? Around the corner from my mother's house, I think. No—across the street. The house that used to be across the street from my mother's house. Where Mr. Ringo's house used to be. Mr. Ringo was the guy who lived across the street from us, and I used to cut his grass and help clean up his house for extra money, and I always enjoyed that because he had a magazine I'd never seen before. Later on, I discovered them at the barbershop. He got *National Geographic* delivered to his door, and he also had other magazines like *Life* and *Look*. But he was a reader of magazines and books. **This is such a colorful picture.** It is. Think about the control you have to have to dribble a ball, pick it up, jump up, pull your arms up as far as you can to overreach the guy trying to block your shot, put the right arch on it so it'll go over his fingertips and into the ring of the basket. It didn't surprise me later on when they started—a few basketball players were taking ballet lessons because they discovered that the body control you need to be a great dancer is the same body control you need to develop as a ballplayer. You look at this and realize it's possible for a kid from the 'hood to be Nureyev.

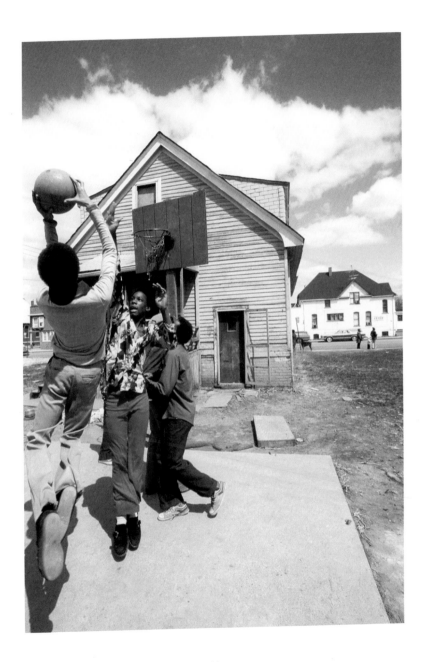

MIKHAIL BARYSHNIKOV

———

When I think about this—look at this picture—I think, Here's the guy who leaps six feet in the air, it seems, and does a pose, but even when he's sitting on the floor he can do something that draws attention to himself. That one finger seems to be one of the signature motions of his genius. He was just. And I'm sure that—all the ways they could—they could have been holding hands and all that, but this one finger touching draws your eye to—into—the picture, like a street sign or something saying, NO STANDING HERE or RIGHT TURN ONLY. **Like the Sistine Chapel.** Okay, I see what you're talking about. **What do you think? Hmm? What do you think?** I see. I see it.

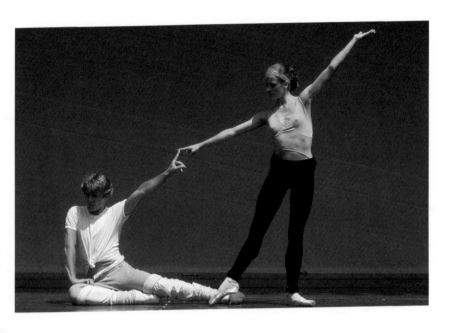

THEY GO STEPPING INTO THE WATER
AND DISAPPEARING

———

You went to the Bahamas with Prince who? Prince Charles. When they gained their independence—the Bahamas got their independence—I went there for that celebration. I didn't know what to expect. **That was the first time you'd been to the Caribbean?** I think it was the first time I'd been out of the country. **When?** Pumpkin, I have to look at when they gained their independence. Maybe it wasn't. It seems like it was in the early '70s. **So when you encountered these boys, they were what now? How did you meet them and what were they?** What was the television show where they were always swimming, deep-sea diving? Up to a point, you've always seen or heard about white people doing extraordinary things and us doing nothing, or just there to pick up sticks or to serve somebody. Here you saw not only Black people in charge of the government, but you saw people doing these things that these guys who were on television were doing. What was it, Jacques Cousteau? It was always the white person who was doing something extraordinary, but these kids did it just for fun. That's the beauty of traveling. Not to say you don't run into racism, but you see yourself through a different prism. And it's extraordinary. I don't know that kid's name. I don't know what he was doing that particular day other than just swimming and diving or what have you. **They were diving to get quarters?** That was among the things they were doing. Diving for change or diving, period. **Who was throwing the quarters?** I guess sometimes tourists. It was almost as if—what they do with animals in a zoo. You realize the so-called animals are more extraordinary than the people throwing the quarters. You'd become famous on television or in the movies if you

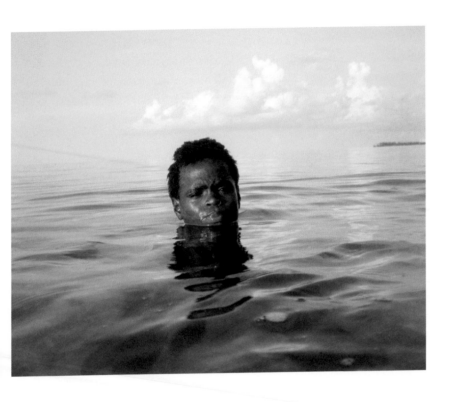

could do the things they did. Not in a submarine or something. **In a scuba suit?** Not all that paraphernalia that they dress up with and walk like so, and they go stepping into the water and disappearing. These kids just do it, and they might stay below the water for two or three minutes! I can't hold my breath that long! [*Laughs.*] You saw the same thing going to—I forget which country it was. When I went to the Olympics in Sarajevo. There was a place before I got to Sarajevo, this little town, where people would dive. From a hill. **A cliff?** A cliff, yeah. Dive and swim a few yards and get up. This is what they did to entertain the tourists. What you see people in the Olympics do, it becomes, My god, these guys are heroes. But there are people who do this for change.

MARSHA HUNT

You ever read any of Marsha Hunt's books? **No.** She's a very good writer. Unfortunately, she's sort of known for her relationship with Mick Jagger, even though she was quite a talented singer and dancer herself. I think she's published about three or four books or novels. The last one she's been working on for twenty years, about Jimi Hendrix. They all hung out together; she was a singer and performer herself, in *Hair*. That was a popular show that was traveling around the world. She hired a palimony lawyer, the guy that was responsible for palimony in California: Basically, a live-in girlfriend is entitled to a share of the property and earnings. If you're living as a wife, then you are a wife. And she was the first one that won a suit against Mick Jagger. They were living in an apartment in England, and Mick Jagger bought the building and gave it to his daughter. And the story goes that the whites who lived in the building—this I haven't seen; I don't know for a fact—but as soon as they ended up owning the building, all the whites moved out. **You said he gave the apartment to his daughter. His daughter with her?** Yeah. Karis is her name. **So Marsha Hunt is "Brown Sugar."** Yeah. **What does she write about?** She wrote a book about her mother. One about Jimi Hendrix; she's very talented. So is her brother. **You're good friends with her brother.** Dennis? Yeah. Dennis and I talk every few days. His birthday is on the seventeenth and mine is on the twentieth. I think I'm a year older than he is.

DAVID HOCKNEY AND HIS MOTHER

The Olympic Committee hired me to shoot all the people making posters for the '84 Summer Olympics, and David Hockney was one of them. **What do you remember about David Hockney?** He wasn't full of himself; he was just, "Wanna see what I've been doing lately? What do you think?" **David Hockney was showing you his collages?** At the time I thought, This is sorta crazy. Building a narrative with images. **His mother was there? What do you remember about that?** She was a lady who loved her son and her son worshiped his mother. I didn't ask, *What is the living arrangement here? Is she here all the time?* or anything like that. [*Both laugh.*] **Were you a fan of his work?** Yeah. I liked that it was ordinary people doing ordinary things. It was sort of like scenes that a baby would create. **How so?** Their simplicity. It wasn't a drawing or a painting of Superman; it was just a guy that jumped into the swimming pool. **Did you see the picture he made of his mother: the collage?** I love it. **What do you like about it?** It reminds me of pictures I took of my mother sitting on the porch, sometimes by herself, sometimes with Aunt Cora Mae. It just represents a moment. There was a guy in the neighborhood who took care of my mother, and, no pun intended, he would kill for her. **What do you mean, "no pun intended"?** [*Laughs.*] **Did he?** I asked him once, "What's the deal with you coming around here, hanging around my mother?" He said, "You know, when I was in jail, my mother died, and they wouldn't let me out to come and see her. So I picked somebody to be a mother to me, and it was your mother." **Well, that's a pretty full-circle story.** That's what art does for you: it takes you on a journey.

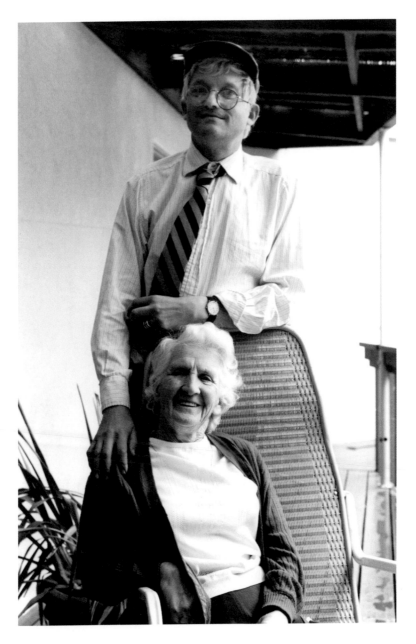

DR. SEUSS

I took your grandmother to visit Dr. Seuss. And we sat in his living room and watched the whales migrate to the south. You could see the whales out his living room window. **He was on the ocean?** He lived near San Diego. The ocean was his backyard. **Didn't you have a story about a student who said something about Dr. Seuss?** Oh, this was a Black student. He said Dr. Seuss taught him how to rhyme. Rap. Why do you ask? **Because some of his books have been called racist.** Before white kids started to rap, they said rapping was racist. **I don't think people would call rap racist today.** But once upon a time they said that. **Do you not believe that Dr. Seuss is racist?** I wasn't a Dr. Seuss fan or anything. I just photographed him. He was cordial. I can't say that I've read everything he's written. **It's interesting, right? That he could have had that positive effect on your student at the same time as he was doing some harm?** Lyndon Johnson was a racist, he called people n*****s and then he passed the Civil Rights bill. People are complicated. Once, I was staying with a friend and he had to run out for a second—I was using the phone and I was looking for a pen and paper, and on the paper was something he had written about a colleague who happened to be Black, and he called him a jive ass n*****. So, when he married {Black celebrity}, he was very happy to become the best friend of the American Negro. Ah, the hell with 'im. **Is he still alive?** Don't know. **This is a person who married {Black celebrity}?** Yes. **So, can I name this guy?** Oh no. **Why?** First of all, what business did I have reading his mail?

———

First thing that comes to mind is the odd couple plus one. I mean, Bush, off to the left, knows something that perhaps Ralph Abernathy didn't know or shouldn't know: that Ronald Reagan cared nothing about equality for Black people. Abernathy had just stepped in as the spokesperson for Martin Luther King Jr. because King had been assassinated. It was after the King assassination that the picture was made. Abernathy had come to the top because he was King's second-in-command. I think Ronald Reagan fought against equal rights and representation for Black actors. He felt like they didn't belong. And I got that from a guy who was around when Reagan was the head of the Screen Actors Guild, or something like that. Maybe it wasn't the Screen Actors Guild, but he was not a person who had a history of fighting for human rights or the rights of Black people. And Bush knows that. If you were to use that picture, that would be fine, but it doesn't ring true. **I look at this and assume nobody is being sincere. It doesn't look sincere at all to me.** It's a photo op. Strictly a photo op. **In Detroit?** No, this was in California. **I thought it said Detroit.** Oh, that's right; that's where the Republican National Convention was. Sort of a last-minute gesture for the Black vote. And I'm sure Abernathy knew he was being used as well, but, after all, he was being acknowledged as the leader of Black people in America. He was. Bush looks like he can hardly keep a straight face. And Reagan looks like he's straining, both to smile and to hold on to Abernathy's hand. It's certainly an example of what pictures— pictures can lie. The gesture, the half-assed smile, says one thing, but altogether it says something else. **I feel like Abernathy's face says it all.** Abernathy—I don't want to say this, but he looks so pleased that

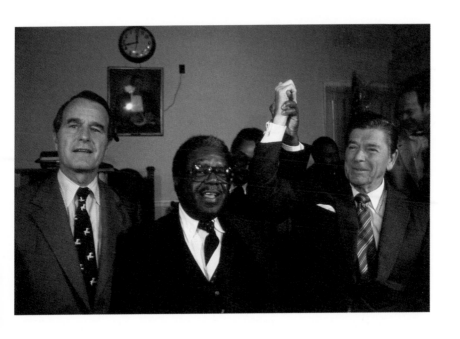

he's there, but he's also aware of the fact that he was being used. **For me, I feel like he's giving you a look, like specifically for you, like *Look at this bullshit*.** See, I guess it depends what you bring to it. I bring something else to the picture, the knowledge that Abernathy is just happy his picture is being taken. What do you see? **I see him giving you a very sly look, like he doesn't trust these people for a second.** That thought hadn't crossed my mind. **Why?** Of course he doesn't trust the people, but if you don't trust the people, why are you there? If you don't trust the people, why let them use you? That's what's being done: he's being used.

CARROLL O'CONNOR

———

I grew to like this guy a lot. When you learn more about him, you like him even more. Norman Lear said the hardest thing he ever had to do was try and put some of the words that Archie Bunker had to speak, to get him to say them. He said he was an Irish liberal who didn't have a racist streak in him. I remember after I shot the cover of him and I was going home one night, I stopped off at a restaurant next door to a bar on Santa Monica Boulevard. I'll think of the name of it in a minute. I went in the door, and he was leaving, he and his wife were leaving, and he looked at me and smiled and said, "Nancy, we're going back inside to buy Lester a drink. Or dinner if you want to." That was the beginning of a friendship. He had this bar in Beverly Hills. He said, "Stop in anytime to chat! You ain't got to buy anything. I know the bartender!" In a way, Archie Bunker integrated television. Later on, there was a show where he played a sheriff. His girlfriend was Black.

JOAN BAEZ

You know, for the singers who came along at the same time, she was like royalty. There was something very elegant and graceful about her, as this picture shows. And she seemed to have a trusting heart. Seemed to be a person who believed in the best in people as opposed to the worst. And she was just honest in how she dealt with people, even strangers. I was a stranger. **Did you listen to her music?** When I met Joan Baez, the world was just—everywhere you looked there was somebody with a different sound, singing different songs. I remember there was a club in LA where all these people appeared, and one night Donny Hathaway was opening for the guy that did the song called "Me and Mrs. Jones." And after Donny Hathaway finished, the crowd was ready to get up and leave, and then the star of the night came on and he had to sing his hit song "Me and Mrs. Jones" to keep them there. And after that everybody walked out. That has nothing to do with this picture, but.

URBAN GLYPH

Would you believe that was a window? It was not that clear and bright and what have you, but it looked like the glass had been scratched. It might have had something painted on it before. I don't know what it is. **It looks like wood.** Well, maybe it was the wooden part of the door. I forget, actually. I associated it with a piece of glass. There was glass there. There was something there. But that's just—you can see the lettering, parts of lettering. **What do you see? What do you think it says?** I don't know. I think the word *chaos* was something that came to mind. **But what's it say?** You mean the lettering? Well, there's a *u* and there's an *n*. Over here, I don't know what it was. **It looks like an *s*. It seems like—in a way, it reminds me of those pictures that were just published of the surface of the sun. Did you see those?** Well, sunlight had a lot to do with what remains on the… No I didn't see those. **It's not exactly the same.** No. A little manipulation with—what do you call them? Pixels. Pixel manipulation, enhancing, intensifying some colors. **You mean just changing the contrast?** That, all of that, is a part of what made this picture look the way it looks. By changing the contrast or changing the intensity of the colors or what have you, it made that which was buried beneath it come forth a little bit clearer. **Like a code?** In a way, a lot of these things you see in nature or in wood grain or patterns and all that is a palette that you can sort of play with and bring out things that are buried beneath. A lot of this thing about urban glyphs is true about these images. **What's an urban glyph?** Those things that will disappear when paper disappears and everything is projected. It's evidence of things that existed at one time, and there was a function for it. It's like hieroglyphics.

CROSSING GOETHE

by Aisha Sabatini Sloan

WHEN I WENT to my parents' house the other day, in what has become a popular area of Detroit, a group of white twentysomethings walked by in all beige—capes and boots and leggings—looking like they might have wandered away from a Burberry photoshoot. Less than two miles from there, in a part of town with far fewer white faces, my father went to gather the last of his family's belongings from his childhood home. "Check for Aunt Cora Mae's photographs?" I asked him. But whoever bought the property after it went into foreclosure had already cleared out the upstairs and put a padlock on the door.

The last time we drove around his old neighborhood, he'd recited the names of his neighbors, repopulating empty lots with a litany of remembered faces: "A guy named Jeffrey Martin lived here. There was a house about here: that's where Danny Collins lived. And you cross Forest: that's where Rodney grew up." As he spoke, the streets came back to life with the sound of boys screaming with laughter.

Halfway between the house where he lived as a child and the one where he lives now, there's a street called Goethe. When my father was young, he and everyone he knew pronounced the word phonetically: "Go-thee." Later in life, he learned German and began to pronounce the street with all the necessary "r" sounds. Whenever we cross Goethe, it is as if we have located the exact intersection that would determine his life's trajectory: a life filled with detours to places like Los Angeles and Sarajevo, only to return. That street is an inception point, ushering him into a bigger world. The discrepancy between these worlds has taken on a greater significance now that

his childhood home sits on a largely vacant block, where squatting families power flat-screen TVs with giant extension cords that reach out to whichever houses still have electricity.

The threshold that more realistically marks where my father stepped into the larger world was the main branch of the Detroit Public Library, located at 5201 Woodward Avenue. While he went to school at Wayne State University, he worked as the manager of the page pool there. For as long as I've been alive, my father has told me stories about a guy named Kurtz Myers, who was the head of the library's music and performing arts department. Kurtz is the guy who suggested that my father perform in the opera *Aida* when Leontyne Price came to town. Kurtz took him on a trip to the Shakespeare festival in Ontario. When Johnny Mathis was on tour, staying across the street from the library, Kurtz said, "Why don't you go over there and say hello?" My dad, who might never have done something like that on his own, knocked on Mathis's door.

In the Detroit Public Library's Burton Historical Collection, which I've accessed online, there is a 1967 photograph of Kurtz Myers looking straight at the camera. He is white, gray-haired, and modestly dressed in a suit and a thin tie, surrounded on both sides by four exquisitely dressed African Americans, three of whom are decked out in furs. Two of the women, gazing down at pictures on the table in front of them, are Eloise Uggams and Eva Jessye, from a touring company performing *Porgy and Bess*.

The photograph was taken by my father, who had recently become curious about photojournalism. One day, he decided to walk his negatives over to *Life* magazine's Detroit office and his career began. *Life* directed him to *Newsweek*, where he would work for the next twenty-five years.

What this archival photograph captures is not just an encounter between a music librarian and a crowd of touring artists, but a mentor gazing at his mentee. The look on Kurtz's face is specifically *for* my dad. It is one of quiet delight. He seems to be saying, *Get a load of this*.

In his career as a photojournalist, my father would interview Black artists and actors to collect their life stories before they were forgotten by history. In 1991, he sat in Rome with a man named Al Thomas, who reminisced about touring with *Porgy and Bess* in Moscow. It was as if, all those years later, my father were still chasing Eva and Eloise.

One afternoon around this time, my father was standing near the entrance to the library when he decided to pick up the phone at the guard's desk and called the loan bureau desk. He wanted to talk to the cute Italian girl who answered the phones there. He asked her out. She was my mother.

On a recent winter day, I ask my parents to take me on a tour of the library where they first met. I'm surprised by how extraordinary the space is. Designed by Cass Gilbert and opened in 1921, the building was constructed in the Italian Renaissance style. At the Woodward Avenue entrance, you pass through bronze doors and you're greeted by a mosaic depicting Copernicus by Frank Varga. Above the grand staircase, ceilings designed by Frederick Wiley show figures from Aesop's fables. The arched, painted windows in Adam Strohm Hall stand almost three times the height of a human being, letting in light through depictions of the zodiac.

My parents reminisce about the friends they made here, and which other couples met for the first time in which elevator. They point to a cart and say, "When he was a page, your uncle used to curl up on one of those things and read." It is a point of pride for my

father, who respects my mother's brother deeply, that he was once my uncle's boss.

When I ask my uncle what he remembers of the library, he recalls the glass floors. "Light came from the floor up. It was not clear; it was frosted, foggy." He would turn off the lights and walk around with just the floor lights on, spooky, glowing underneath him. There were floors and floors of stacks that were unseen by the patrons. "But the rooms are so tall," I say, thinking of the majestic space where a mural of a man's upturned face and neck spans three arched sections, majestic as the Sistine Chapel, a triptych called *Man's Mobility* by John S. Coppin. My uncle remembers a mazelike place full of wonder behind and below, floors stacked in a way that brings to mind Borges's Library of Babel.

As we walk past an enclosed area, the E. Azalia Hackley Collection of African Americans in the Performing Arts, I notice a flyer for an upcoming lecture on Lionel Richie. I'm a child of the '80s, and the sight of Richie's album covers, especially *Can't Slow Down*—white room, white pants, small 'fro, backward chair—transports me right back to the gray-carpeted living room where I choreographed dance routines as a kid.

On the night of the lecture, I return to the library with my parents. The music librarian, Romie Minor, reads from a binder full of laminated pages. He tells us that when Lionel Richie was a child, his grandmother played Bach and Mozart for him. Later, he studied to be a priest. But "he was not priest material." A man in the back of the room laughs.

There are folding chairs for around thirty. Eight of us are here.

Romie Minor says, "Let me play this one for you." He puts a CD in a boom box situated on a desk at the front of the room. As the music plays, a woman in a yellow pantsuit says, "There it is."

When we'd first walked into this book-lined room, Minor had been prepping. At the top of the hour, he picked up a microphone and began to sing "Oh No" by the Commodores. "I'm going crazy with love," he spoke-sang, then leaned over to the woman in the yellow pantsuit, who had cooed back: "Over you."

My dad had picked up his camera. We were in the same room where he'd snapped that picture from the archives fifty-three years ago.

Over the course of the evening, Minor describes the highs and lows of Richie's career. A slideshow with album covers plays on a television standing on a rolling cart.

The audience thrums:

"That's a jam"

"This music represents about two-thirds of my kids. That's how they got here."

"Lord have mercy."

"Can't remember my address but I remember that."

When "Easy" comes on, almost all of us sing. Minor's manner is quiet but totally hooked in. He holds court with the audience without raising his voice or really even modulating his tone. This contrasts beautifully with his body language, which is similarly contained, but with flourishes. With each new song, he throws his hands out like he is splashing water. In a monotone, he punctuates the gesture: "Crossover hit."

A library security guard, who has wandered into the lecture on his break, closes his eyes. He says, "I spent a lot of time on the dance floor to that one."

Minor starts to talk about the tension within the Commodores when Richie began to get famous. The library audience is definitively Team Lionel. They respond to each fragment of Commodores-versus-Richie gossip with an elongated "Mm-hmm."

When "Endless Love" plays, and Diana Ross sings "Bum, bum, bum" along with Lionel Richie, a member of the audience in a beret plays an imaginary electric guitar.

"I don't know what he was doing out on the road," Minor says.

"Yes, you do," somebody responds, insinuating something salacious.

I get emotional when Minor puts on "Nightshift." It was the Commodores' first hit without Lionel. It is one of my favorite songs of all time, and I'm not alone. In an interview on the radio program *On Being*, Claudia Rankine talks about the time she sang "Nightshift" from start to finish with a stranger on a plane.

As we listen to "Hello," Minor tells us an anecdote about the song's famously melodramatic music video: Apparently, Richie had disliked the bust that the fictional blind student sculpts of his likeness. He claimed it looked nothing like him. "But she was *blind*," the director explained. My dad stage-whispers: "So she was sculpting his *voice*."

I tell my mother our parking meter is about to expire. My dad raises his hand and explains that we shouldn't be surprised that America's greatest export is our culture. He tells a story of being in Berlin as the wall came down. How the East Germans had sung Black American music and called out to him in solidarity. "Anyway, we've gotta go," he says. The talk is far from over. I apologize a bit too profusely, cheeks burning, as we all get up to leave.

On the way out of the library, I see the security guard, who has since returned to his shift near the exit. "Do you go to these talks often?" I ask. "Oh, yeah," he says.

My mother has recently told me about the time when she was in the library basement on a break, and a security guard, a man she liked very much, came down to eat his lunch. He put his plates away, stabbed himself, and later died. "It was awful," she said.

That night, I think of the security guard we met, working the remaining hours of his night shift. Ordinary life continues in this city despite all its extremities—water shutoffs and casino lights, Burberry-draped hipsters and foreclosed homes. And amid all that, in the main branch of the public library, there's a small room of people chuckling quietly while listening to albums on a cold winter night.

As we leave the building, we pass the reception desk. My parents restage their first conversation:

"I was here," my dad says.

"No, you were over there."

"And I called."

"Yeah, I picked up the phone, and I said, 'Who is this?' And you were standing right over there."

TWO GUYS ON A MOTORCYCLE

This is when the pope was visiting California. **You'd encountered him before this?** In Mexico. He was scheduled to visit a hospital or something like that. We were on the bus and the bus stopped and Owen and I jumped off to try to get a position ahead. The bus only stopped for a moment and it took off. Owen got on the bus and I didn't, and I ended up flagging down two guys on a motorcycle. They were sitting at the side of the road waiting to see the pope. I jumped onto the motorcycle between them, loaded down with cameras, speaking no Spanish, saying something like "Go, go, autobus, autobus, mucho dinero." We started riding down the freeway against traffic—but the traffic had been stopped, so there was no traffic allowed. And the pope was in the pope mobile; he looked out and saw us and blessed us. **Were you taking pictures?** No. I was trying to hold on for dear life as we were trying to catch up with the bus. There was a press corps from the motorcade, a TV crew, and I jumped into their van, and we went up the road. I got there as the pope was going to a hospital. I was on the stairs as he was coming down, and he passed me and said, "Are you all right, my son?" I forget what year it was that he came to LA. He was speaking at one of the movie studios, taking on the movie industry, talking about the amount of violence and sex in films. His talk didn't go over very well with the people in Hollywood, but they were polite. I was standing, taking pictures, and he stopped when he got to me and looked at me and said, "How are you, my son?" And I said, "Fine, Father, how are you? Good to see you." I think he blessed me or something and walked on. Now, Nick Ut is shooting on the other side of the room and he shouts across the room, "Lester, how do you rate?" In other words, *He didn't stop to talk to anyone but you!*, and I said, "We go back a long way."

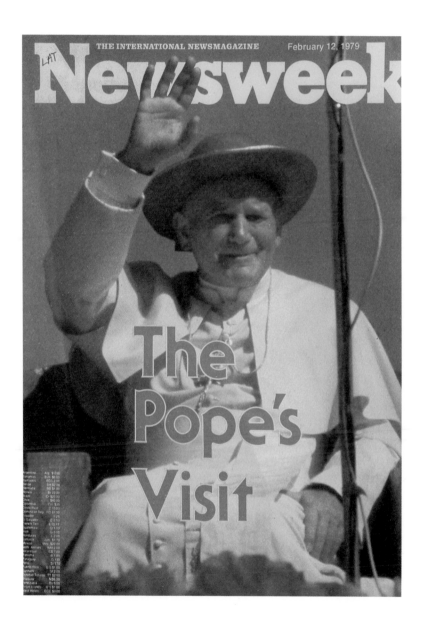

———

Now, this is the worst picture of her. **Who?** Kinski. **That's Kinski?** She made over sixty movies. Her father was a great actor named Klaus Kinski. **Wasn't she a great actor?** Sixty films was quite a number of films to be made. **I think she's a great actor.** I thought she was a wonderful actress. When she was dating Quincy Jones and she was going to an Academy Award thing, and she was with Quincy Jones, and now maybe this is because the interviewer said, "Quincy, can we talk to you for a minute?" And he left her on the side. And I thought that was so rude. And, I mean, Quincy Jones is a great arranger and director and this, that, and the other, but— **Isn't that a pretty normal thing to do when you're at an awards ceremony?** It's up to the person being interviewed. **Well.** If nothing more, it's a courtesy. If you bring this person to the event, you don't have to ask her any questions, but, I mean, come on. Actually, she had a baby by Quincy. Again, never talked about. **What do you mean it's never talked about?** All the other Quincy Jones kids had their share of the limelight. **Well, maybe her daughter didn't go into acting.** She didn't go into acting? **I mean, it's not to say they didn't have a relationship.** No, okay, Pumpkin. **Do you not like Quincy Jones or something?** I think Quincy Jones is fantastic. Great. I just thought it was rude. I've seen people come with their wives or their dates or whomever, and the interviewer says, "And who is this lady?" If they don't know. **I just think I see people do that all the time.** Well. Maybe it's because I thought she was a very nice young lady. That people do it all the time doesn't mean that that's the way it's done, that that's the polite thing to do.

TEN GRAND ON HIS PERSON

This guy started an airline. **This guy?** His name was Ken Moss. **It looks like he was charged with murder.** By whom? **By the authorities.** And did he go to jail? **For 120 days. Manslaughter.** Because somebody died where? **He provided narcotics to somebody who died.** Yeah, well. I don't remember Ken Moss serving any time. I remember him catching hell from the airline industry. It was an airline that flew between Los Angeles and San Francisco to Europe. It was kind of a countercultural airline. All the seats were the same price. You could sit where you wanted to sit. And that eliminated this whole thing about first class and second class and third class. Anywhere on this plane was just fine. Usually, this attracted a group of people who ordinarily couldn't afford to go to Europe. **I thought it just went to a couple of places.** Yeah, well, Pumpkin, if you went to Geneva, Switzerland, where this plane ended up, you could rent a car and drive to France. Or you could get a train ticket and go to France or wherever you wanted to go. The reason it only went to Geneva is because the airlines threatened the gasoline company: *if you let this guy land here, we will stop flying for your airport.* So they wanted to put him out of business, which they succeeded in doing. We went on the maiden voyage, Peter Greenberg and I, and it was the craziest flight you'd ever want to see. I mean, people— **People what?** It was wide open. You could sit anywhere you wanted to sit, people were dancing, laughing, and talking. I mean, some of the restrictions about flying, being seated when you take off and all that, they threw all those rules out the window. I remember we landed in an airport to refuel, and some of these people that'd been on the flight had stayed at a hotel and they had skipped out without paying their bill. And the police

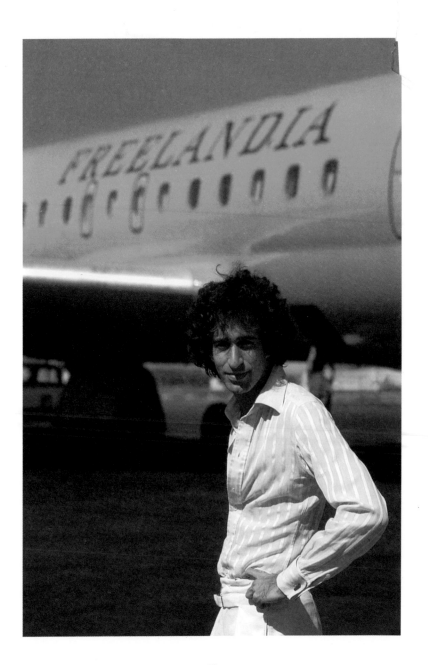

were called, and they came to the airport and stopped the flight from taking off. There was a guy on the plane that had ten thousand dollars in cash. He was a drug dealer, I'm sure, and he threw the money out the window of the plane, onto the ground, to pay for the hotel bill. And the plane took off. That's how crazy it was. **While you were on the plane?** Yes! They stopped the plane from taking off! Because the hotel said people had skipped out and didn't pay their bill, and it amounted to something like nine thousand dollars, so this guy had ten grand on his person and he threw it out the window, the cops picked it up, and the plane took off.

———

A lot of people think that Blacks in Germany go back to the First World War, especially American Blacks, but there's been Black people in Germany for years. I mean, decades. **When did you first go there?** I first went to Germany in the '70s. **So you found yourself in Frankfurt?** Yeah, I was in a train or a bus station or a metro station, and this picture sorta sums up my situation and that of the young Black man not wearing military clothes, wearing civilian clothes, and the shadow he cast on another culture. He looks like a stranger, but he's at home in another culture. **When you went, were you surprised to find young Blacks there?** More like shocked. I remember when the wall came down, an American politician who was Black came to Berlin—Ron Brown, he was the secretary of commerce. And there was a German politician showing him around. I had told my friend John that this guy was coming and it would be great to meet him. John was there, and he went up to the American politician and said, "So are you aware there are Blacks in Germany?" And the German guy from the Democratic Party of Germany interrupted and said, "Yes, and we have programs for foreigners." And John corrected him and said, "We're not foreigners. We were born in Germany. Germany is our home." And the guy was taken aback. But it showed that German politicians always considered Blacks outsiders, even those who were born there.

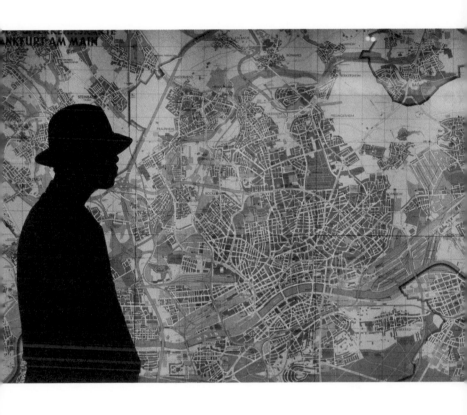

THE BRANDENBURG GATE

———

On the day of the reunification, I said to John Kantara, "Let's go to the Brandenburg Gate to celebrate." And I thought he was joking, but he said, "The beast will show its face tonight." He was talking about the neo-Nazis. I encountered them when I went out alone to the Brandenburg Gate for what I thought was going to be a celebration, but they were singing "Deutschland uber alles," "Germany is the greatest," and throwing firecrackers at my feet.

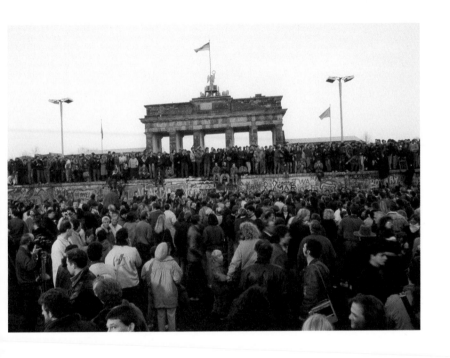

THE RHINELAND

I was recording or interviewing her, and she left the room and she came back and she heard the tape playing and she said, "Oh, oh, my god! That's my sister!" I said, "Where?" She said, "I hear her talking." I said, "That's you." She said they sounded like each other. **What happened with the doctor, though?** He falsified the papers saying that he'd performed the sterilization procedure on the two of them. Because they were supposed to have been sterilized. And there's a book I have called *Sterilisation der Rhineland Bastarde*. The Rhineland was an area where Black soldiers were stationed after the First World War. So they had a policy under the Hitler regime to sterilize all those women so they couldn't bear any more children.

———

What do we want to say about this guy with the Diebenkorn? Look up "Cher's manager." He's an important person. **Roger Davis?** No. This guy is a producer, agent. He's a gazillionaire. Hollywood producer, agent, with an outstanding art collection. He's given art to the museums. **Who else does he manage?** He's a big political donor. Google: "biggest Hollywood producer and contributor to Democratic party." Doesn't he look like a little kid? Look up "biggest art collector in Hollywood." **David Geffen.** There he is. **He is seventy-six.** Seventy-six? You gotta be joking. He looks like a child here. **What do you remember about taking those pictures?** I remember him being just a super-nice guy. Not full of himself. Just "What do you want me to do?" Stand here, go there. Can you sit down on the floor? **It says he and Cher almost got married.** Well. I mean. That would be more for Cher's protection when she was married to that dominating ass Sonny. [*Reading aloud from the* Hollywood Reporter.] **"Geffen's first move was to free the singer from her onerous business arrangement with estranged husband Sonny Bono."** Well. Sonny Bono was sort of a thug with limited talent, and he was a control freak. Geffen at the time was in a relationship with a fashion designer. Who were some of the men's fashion designers? Or designers, period? **Calvin Klein?** Yep.

CASABLANCA

It was Rodney's idea to put the cigarette in his hand. He didn't smoke it or anything; I don't think he smokes to this day. The picture reflects the father more than the son, though the son takes good instruction. He was an old soul then. I guess he was about ten or eleven at the time. **What do you mean it reflects the father? What does it reflect of Rodney?** Rodney was always about the movies. You give him the name of a movie, or a star or an incident, and he will tell you more about the picture than you actually want to know sometimes. He's—we had a mutual friend who used to refer to Rodney not by name but by "Just like in the movies." Rodney was a movie fanatic. We were playing that the other day; we were talking about movies, who starred in *Shane*, and he gave me the name of the star, when the movie was made. That's one thing about him that never changed. He may have gotten older. Smoking was something, a habit he may have gotten from watching some of his favorite movie stars. You light up a cigarette and then he'll mention a movie, and then he was off. **What's his favorite movie?** If I were to guess, it would be a movie that—not Humphrey Bogart but, um, I can see the singer in the movie, who was a very famous Black entertainer in New York. *Casablanca? Casablanca.* **Was Rodney like this when you were kids?** Rodney was never a kid. He was always Rodney. Even now that Rodney is eighty years old, he's still a kid. **You said he was never a kid.** He was never a kid; he was always a character from some movie he had seen, or, even when he was a younger person, he was always living a scene from one of his favorite movies. I remember once I called him; I had a habit of calling Rodney wherever I went in the world. Once, I was in Paris, I was on the Champs-Élysées, and he said, "What are we drinking?" And I said, "Glass of wine, Macs."

THE WOODLAWN MAFIA

What was the story behind this picture? They were the story. **What is the story?** Black life in LA. You know, I took the picture because I asked them if I could take the picture, first of all. This was their turf. The reason I asked was because with gang members, you don't go around taking their pictures and not letting them know. **They seem informed.** I was out one day taking pictures and what have you, and the person I was with told a guy that I was from Detroit and the guy's whole attitude changed. Because he had said something like "Hey, MF, what the hell you taking my pictures for?" The guy said, "Chill, this guy's from Detroit." Detroit had a reputation that they attributed to anybody from there. You got your gang members in LA, but n*****s in Detroit are crazy.

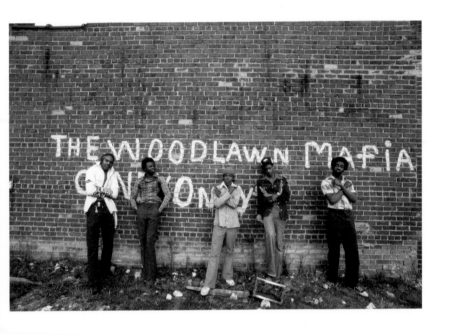

BARBER AND SONS

I like the shirt that the guy's wearing. I think it says WAKE UP, BROTHERS. It's an old picture but it deals with what's going on today. An awakening for Black men.

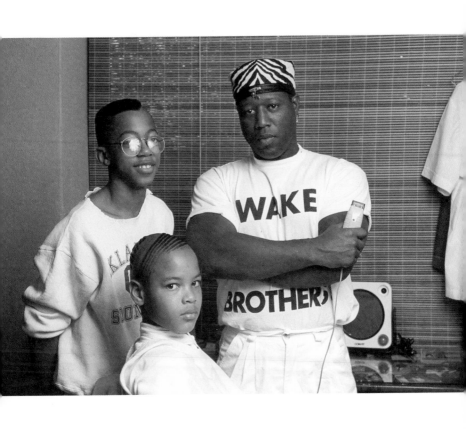

MARVIN GAYE

———

I'm surprised we never had him over to the house. He lived right down the street from us, just before you got to Sunset, going down Barrington. He lived on Barrington. **So you went over there?** Went over there, we played basketball outside. Then we lifted weights. Then he went inside and his wife was cooking something to eat, and he started putting on records and singing along with the records. Talking about Detroit, what he didn't miss. I think he had just moved back, came back to the States from Europe. **And what was he singing?** His biggest record then was *Let's Get It On.* **Wasn't that right before it came out or something?** Yeah. There was a reporter at *Newsweek,* and when I told her I went to photograph him, she got actually physical, started punching me. [*Laughs.*] "Why didn't you tell me?" she said. I said, "Okay, I'm sorry, I'm sorry. It was just a spur-of-the-moment thing." I think we had talked, you know, the picture I have of him at the church? Bobby Jackson's church? **No.** I had approached him about taking pictures. Because it wasn't through his agent or anything; it was just through a guy we had both grown up with. Bobby had moved to California and became a minister, and he announced to the congregation that he was the associate pastor; he wasn't *the* pastor, but he announced to the fellowship that they were going to have special guests coming next Sunday. I have those pictures around here somewhere. Bobby's in the pulpit, and he said, "I want my good friend to come up and bring the word to you," or something like that. And Marvin Gaye popped up out of a seat, or came from the back of the church, went onstage, and started singing the Lord's Prayer. **How did people react?** Stunned. Stunned that, first of all, this was Marvin Gaye, and the little associate pastor that

nobody knew anything about had invited a friend. **From Detroit.** St. Rest Baptist Church. **They knew each other from Detroit?** They knew each other from Detroit. Listen, Bobby's first profession was a pimp. So, and that's another interesting story.

PATTY HEARST'S AUNT

———

This is Bobby Jackson at St. Rest Baptist Church. Bobby was an absolute charmer. He was just funny. I remember he called me once when he was still living in Detroit, and he said he was coming out to California; he didn't know anything about the place. I said, "C'mon." I used to take Bobby with me on assignments. When Ford left the presidency, he moved to Palm Springs. And I was given the assignment of going down to photograph Ford's new neighbors. Now, Ford's new neighbors included people like Frank Sinatra and just about every celebrity you could mention. And I had no way of getting to these people. Apparently, in New York they thought you could just knock on the door and say you're here to photograph, but anyway. I hired Bobby to go with me, and there was—who was Cher's designer for a while? Bob Mackie. I had photographed Bob Mackie, and I called him to ask if he could give me a hand; I had to meet some of these people down there; I needed an entrée. He said, "I'll get back to you." Then he called me back and he said, "Patty Hearst's aunt lives in Palm Springs. Call her at this number and she'll help you." After that, everything changed. [*Laughs.*] I took Bobby with me, and she thought Bobby was the most fascinating man she had ever met. **Patty Hearst's aunt?** Yeah. She was just, I mean, he was so attentive; Bobby would be there with a match to light her cigarette and all that. He was quite attentive. And she couldn't do enough for us. It was funny: Ford, one of the days we were with him, he was going to be playing golf, and it turned out he was playing golf with a Black golfer that Bobby used to play golf with. And the golfer saw Bobby and he saw the two of us. Bobby was waving at him and saying, "Hey!" And the guy was turning his back. I'm sure he was

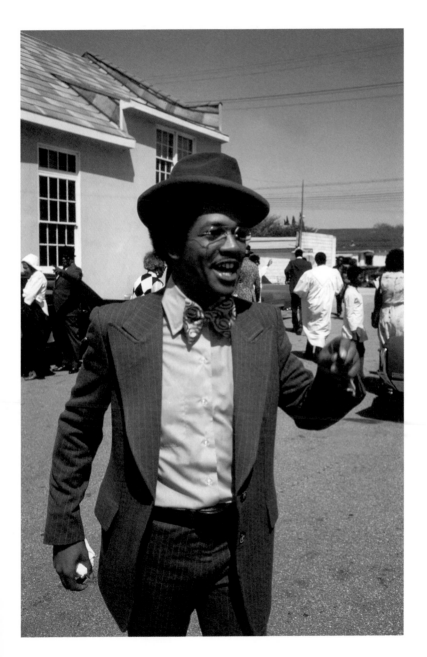

thinking, This is the biggest day of my life. I'm playing golf with the president, and here's a n***** from Detroit who I played with a few times, and I don't want the president to know that I know this guy! Bobby would wave at him, and he would turn his back. So Ford walked over to us and he said, "Look, you guys getting everything you want?" And we said, "Thank you, Mr. Ford, fine." And he said, "Let me know if you need anything." The guy saw the president talking to us, all of a sudden he's now waving at Bobby: "Bob! Bob! My man!" And Bobby looks at him and says, "Fuck you."

TIPPI HEDREN'S TIGER

Tippi Hedren was the mother of a famous actor. Well, she was a famous actress herself. **What was going on in this picture?** They're just actually showing me one of their pets. They had a zoo or they had a place where they had these big cats, and they were quite docile; they were just big cats. Scared the hell out of me when I was there because one of the lions yawned and opened its mouth, and it was wide enough for a small person to be swallowed whole. **Were they tied up?** Nope! Do they look tied up? **So you were just there with them, hanging out?** I went to take pictures of them hanging out in their zoo. She made a movie. Remember the movie? Well, you probably don't remember it. Tippi Hedren starred in a movie directed by—what was the big fat guy with a round face? **Hitchcock.** Alfred Hitchcock. *The Birds?* *The Birds.* **Melanie Griffith's mom?** That's Melanie Griffith's mother, yeah.

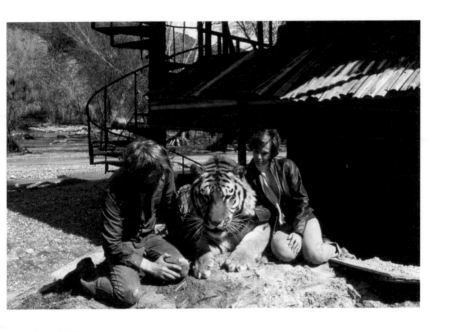

ALFRED HITCHCOCK

———

He was just another Hollywood mogul who figured he could do anything he wanted with people. **She [Tippi Hedren] accused him of assault.** Huh? **She said he assaulted her.** Well, he did. The face I find most interesting is Mrs. Hitchcock's, sitting to his right. She could care less about this. She's only there because she's expected to be there. Alfred Hitchcock was the king during this time. And everybody wanted to be in a movie directed by him. That's old Hollywood. New Hollywood was no different.

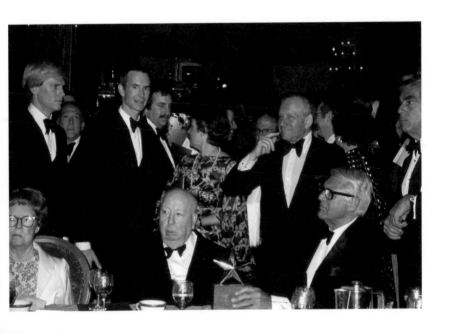

JOEL FLUELLEN

Joel Fluellen was just a delightful storyteller, and he had been around Hollywood when the only roles that you had were being a butler, if you couldn't dance or sing. There weren't many roles for Black men, or Blacks, period. His story was interesting as well. He didn't come to Hollywood; he found his way to Hollywood by accident because he had to get out of, I think, Louisiana because he'd had an altercation with some white guy: he punched him out and he went home. He was young, too, sixteen or seventeen, something like that. He beat up this kid and got home and his mother had already heard about it, and she had already packed him a bag. He went to hang out in the hobo town where people jumped on trains, and that's what he did. Ended up in Chicago, from Chicago ended up here in California. In Los Angeles. He worked around as a cook, this, that, and the other, got bit parts in movies, and he turned out to be not superfamous, but he made a nice living. I know Beah Richards thought Joel and I were lovers.

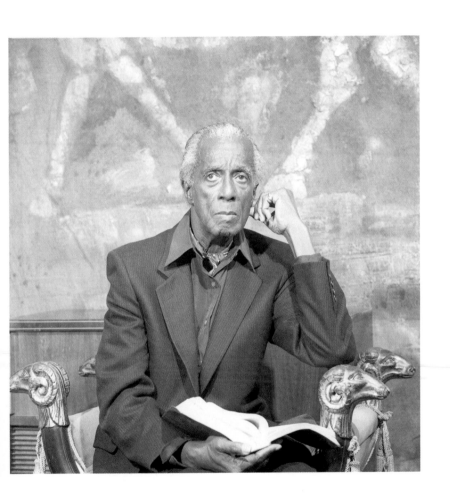

BLACK HOLLYWOOD

by Aisha Sabatini Sloan

BEFORE HE DIED by suicide, Joel Fluellen acted in forty-seven films. He was a henchman, a kitchen worker, a customer, a court clerk, a Black man in a jail cell, a waiter, a servant, a sailor, a florist, an attendant, a handyman, a porter, a witch doctor, a judge, a cab driver, a convict, a policeman, a fisherman, a soldier, a bartender, and several African natives. He was a member of Hazel Scott's group, Toussaint's Aide, a Harpers Ferry station master, and Kyle's associate. He was Matambo, Molu, Arobi, Tick, Bragg, Bobo, Abram, Williams, Robbins, Pete, Al, Jack, Nathaniel, Cody Marsh, Charlie West, Jimmy Judson, Bill Lake, Lester Johnson, Uncle Rob, Mr. Kelso, and Mr. Holland. He was Sam a few times.

As a teenager in Louisiana, Joel got into an altercation with a white man. By the time he got home, his mother had packed his bags. He lived in a hobo camp, my father tells me, jumping trains. He rode out to Chicago and ended up in Los Angeles, where he started acting.

Toward the end of his life, Joel lived not far from our apartment in West LA, right off Pico Boulevard. My father was interviewing Black actors at the time, and Joel introduced him to everyone there was to know. "What was the project for?" I ask. "For myself," my dad tells me. He does this sort of thing: gets on an interviewing kick, accumulating tapes that fit into categories like Black Hollywood, Ollie Harrington, and Afro Germany. "I will not talk about Dorothy," Joel told my father when they first met. "Dorothy who?" my father asked. Apparently, Joel was close friends with one of the biggest Black actors of the time, Dorothy Dandridge.

As his friendship with my father deepened, Joel told him he had never called Dorothy back when she reached out the day before she killed herself. This fact finds a mirror in my father's friendship with Joel. One night, as my father prepared to leave, Joel tried to give him a stack of items. Joel told him, "I'm so scared." My father tried to comfort him, told him he'd come back later, but he had another actor to interview. The next day, my father couldn't get ahold of Joel, so he called the fire department, and they broke down his door. "You don't want to go in there," they said, after taking a look inside. He doesn't discuss his own feelings about the day before the actor died, but my father does perform Joel's response to missing Dorothy Dandridge's call. "I don't have time for this," he says, in imitation. He plays up Joel's exasperation with Dorothy, as if to lampoon the folly of it, infusing the words with, I imagine, the tension of his and Joel's retroactive remorse.

In a video my father took of Joel, the actor wears a turtleneck and a plaid blazer. I've raised the volume all the way up, but there is no sound. I begin to seek out Joel's films. I'm particularly interested in Joel's eyes, which have a long quality, a distance inside them. Many of his films are available in their entirety online. He plays the lead in a 1945 recruitment film made by the US Navy called *The Negro Sailor*. He goes through basic training in a series of scenes that have, in my opinion, extreme, if inadvertent, homoerotic undertones. Five years later, in *The Jackie Robinson Story*, he plays Jackie's brother Mack, cheering alongside Ruby Dee from the stands. It's hard not to superimpose Joel's actual life onto these scenes—to wonder what it was like to be young and gay and Black in LA in the 1940s. My father recalls that Dorothy Dandridge told Joel some gossip about a man and a woman who were both having an affair with the same director. I find a photograph online of Joel sitting beside Dandridge and Burt Lancaster on the set of *Run Silent, Run Deep*. It's the kind of image that holds about fifty films inside it.

I search for footage of Joel in his final film, *Butch and Sundance: The Early Days*, but the quality of the film is too poor. If Joel as Jack the Bartender is making drinks somewhere in the background, I can't make him out. In the video my father shot, Joel has a rigidity about him, the kind of formality that calls attention to the question of softness: Where did he find or search for it? At Joel's funeral, my father told the room, "Joel died of loneliness."

During their conversations, Joel told my father about one of the many times he played an uncredited native and was asked to speak gibberish in an approximation of an African dialect. They were crossing a body of water alongside some elephants when all of a sudden, a male elephant started to trumpet. I'll let my father tell it:

The females got excited, and they started defecating in the water. And Joel and their characters were supposedly leading the elephants across. And when the elephants started pooping in the water, Joel said, "Out! Cut, cut, cut!" He said, "This is stunt work. We ain't doing this for no five dollars a day." They agreed to pay the stunt fee, which was like fifteen dollars a day. I said, "Joel, the first strike for Black people in Hollywood was over some bullshit?" And he said, "Yeah."

It's interesting to me that my father was fascinated with actors for so long, when his job as a photojournalist tasked him with documenting real life. Perhaps he got tired of the news. "What do you think," I try to ask him, "about the art of projecting oneself into a fictionalized self?" As if in response, he tells me he was once hired to play himself in the Spike Lee film *Get on the Bus*. He thought he'd been hired as the set photographer, but apparently they had hoped he would act as well. In the end, he stayed offscreen. He spent time between takes listening to Ossie Davis tell stories, like about how

when Malcolm X called him before he was assassinated to tell him he felt he was being hunted. My father, around that time, was exhibiting all the signs of a midlife crisis. He grew out his beard for the first time in decades, and to his surprise, it was bright white. In this sense, he showed up on set in a kind of costume. I try to imagine what it would look like if he'd acted in the film, after all—playing his own, bearded alter ego, a photojournalist from Los Angeles catching a ride to the Million Man March in DC. I try to imagine the quirks of his personality that would have established him as a character: how his eyes go blank when he tells a joke, right before he lets a smile spill across his face. How he looks off into the distance, shrugs, and says, "Anyway," before getting to the heart of whatever it is he's talking about. How instead of pointing, he extends an upward-facing palm, as though imitating a teakettle or waterspout.

In some of the tapes my father recorded with Black actors, he doesn't even ask about Hollywood. During a conversation with Bill Walker, who played Reverend Sykes in *To Kill a Mockingbird*, my father asks Bill to talk at length about a girl he had a crush on as a kid. He keeps returning to the story over the course of the interview. I fall asleep to the dulcet tones of this back-and-forth. When I ask my father about it later, he remembers the story of Bill's crush vividly: "Well, that was an interesting story. Years later, they ran into each other at a funeral." It's as though my father is searching for the dramatic arc of Bill's life, the movie of it, locating the underlying tensions, sketching out the tune of his personality for an orchestra to play.

My father recalls Bill telling him that Gregory Peck thanked him while accepting the Academy Award for playing Atticus Finch. I search YouTube and play the footage for my dad over the phone. The acceptance speech is short and perfunctory. At no point does Peck make mention of Bill, whose big line involved telling Scout to stand up when her father passes by in the courtroom. My father and I sit in

momentary silence. He wonders aloud if Peck said something about Bill on his way off the stage. I imagine we both feel embarrassed about getting our hopes up. Why would the star of a film thank an actor who was not even credited for his role in the film? Watching the speech with the expectation that it will end differently reminds me of when *La La Land* was given the award for Best Picture. But in that case, the impossible happened. Remember? The *La La Land* people were three speeches in when it became apparent that *Moonlight* was supposed to have taken the award. The producer snatched the card away from Warren Beatty and showed it to the room. The camera zoomed in to verify. The producer of *La La Land* sounded frustrated, as if he understood the way history culminated in the moment, and he wanted to give *Moonlight* its proper due. He said, emphatically, "This is not a joke."

In one video with Joel, a woman named Eula Williams enters the frame. She is the widow of the actor Spencer Williams, who played Andy on the sitcom *The Amos 'n Andy Show*. The NAACP fought to have the show taken off the air for its negative portrayal of Blacks. And it's true—the show had its roots in a minstrel act from the radio, which originally starred two white men. But Joel and Eula point out that while some of the characters were cartoonish, at least there were doctors and nurses. Roles more dignified than "native," "servant," and "Black man in a jail cell." It was Spencer Williams's big break, and he never got to play such a big role again.

In addition to being an actor, Spencer Williams was a director. I watch one of his films, *The Blood of Jesus*, in which an injured woman is visited by an angel, who takes her spirit to the intersection of heaven and hell. The actors, Spencer Williams especially, have a comical air about them, giving side-eye during moments of dramatic tension in a way that makes the performance feel surprisingly modern. The special effects are reminiscent of Jean Cocteau's *The Blood of a Poet*,

or, more recently, the work of Michel Gondry, wherein dramatic story lines are paired with a puppetlike attempt to convey something metaphysical, creating an atmosphere of magic and deep nostalgia. I am reminded in particular of Gondry's *Be Kind, Rewind*, in which Jack Black and Yasiin Bey use wire, paper and glue to create an epic, fictionalized version of the life of Fats Waller for their New Jersey neighborhood to enjoy as it is projected onto the outside wall of a video store. It is a celebration of Black artistic ingenuity that seems to blast gratitude backward, in an attempt to reach the artistic dead. The films Williams directed were not given much recognition until after his death, when *The Blood of Jesus* was put on the National Film Registry for being deemed "culturally, historically, or aesthetically significant." It now lives alongside the Italian neorealists in the Criterion Collection.

In my father's video, Eula Williams recalls her husband's decades-long grief over the life he never had in Hollywood, especially toward the end, when he developed Parkinson's disease. He would get up in the middle of the night, put a suit on over his pajamas, and wake her, explaining that he had to get to the work. He didn't want to keep the studio waiting.

Recently, I began watching the TV show *Lovecraft Country*. I am overwhelmed by the fact that Jurnee Smollett and Jonathan Majors have been granted the opportunity to play characters with such range and exquisite costuming—they fight monsters in the forest, bash in the car windows of white supremacists, and evict the ghost of an evil, racist doctor: roles that Joel, Spencer, and Bill never got the chance to play.

Another actor with whom my father became close friends was Beah Richards. You might remember her from the film adaptation of Toni Morrison's *Beloved*, in which she plays Baby Suggs preaching in a sun-dappled forest. She says, "Let the children come. Let your

mothers hear you laugh," and children swarm around her. It is a scene of renewal—men are called to dance, women are asked to weep for the living and the dead. According to my father, Beah was asked by the director, Jonathan Demme, to improvise the speech herself. This might explain its power. In the documentary *Beah: A Black Woman Speaks*, the actor says of her father, "He was a minister. A preacher, they called it. My father was a poet, he was a good poet. He *sang* his sermons. He *sang* them. There was a truth, it has a ring, they say, that makes the hair stand on end, or skin, the goose bumps, jump out, or a chill runs down your spine. He had that magic. Ooh! If I could have been the kind of actress that my father was a preacher, oh!" Her manner, which gives *me* goose bumps, explains why my father would call her, periodically, and say, "I need a Beah fix."

In her documentary, Beah Richards says, "The question a human being has to answer is 'Who or what am I?'" I am reminded of the end of *Moonlight*, when Kevin and Chiron are standing in the kitchen, stripped down to the bone, emotionally. Kevin asks the man he fell in love with as a boy, "Who is you, man?" And that's the beauty of this movie, isn't it? The film won't tell us who Chiron is ("sailor," "soldier," "florist"). The film is asking.

At the 2017 Academy Awards, Hollywood finally told us, albeit by accident: "We made a mistake." I don't know about you, but I played the moment over and over again, as though it were proof of the divine, a rendering of Jesus's face on a piece of toast. The beautiful stars of *Moonlight*, some of them just boys at the beginning of their careers, rose out of their seats, preparing to take the stage.

BEAH RICHARDS

So did you interview Beah Richards too? Yeah, Beah Richards and I became great friends. **You called her up and then what happened?** I'd call her up. She lived not too far from us. She lived well, but nothing fancy. Beah was quite amazing. She had done everything from the classics to—she was a great dancer. Nobody knew her for the dancing she had done, but she was totally the opposite of most of her roles. She played Sidney Poitier's mother in *Guess Who's Coming to Dinner*. She was always playing somebody's mother. **Would you go over to her house? What was your friendship like?** She'd invite me to come over and chat, or for dinner. She even asked me to take her to an event where she was given an award at the Pasadena Playhouse. I remember I was the leader of a discussion when Gordon Parks appeared at the African American museum. I was the moderator for the show they were having. And I saw this woman and I said, "How is Beah?" And she said, "Dead." I said, "What are you talking about? I was gonna call her," and she said, "When you get those feelings, act on them."

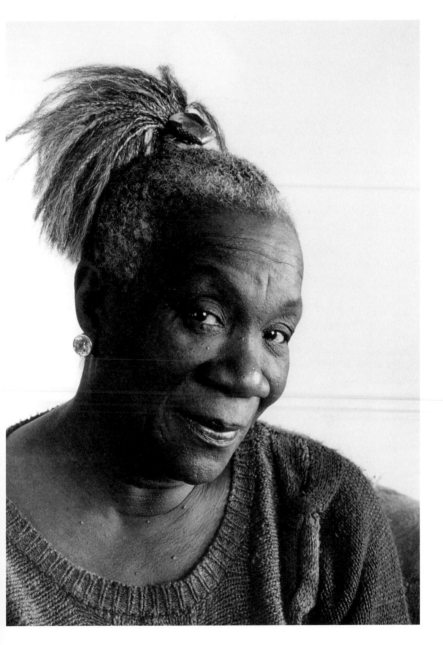

———

That's at a press conference with Jackie Gleason. **It doesn't really look like him.** That's when he made the movie *The Toy*. **What'd he say about it?** He said he made it because he owed somebody a favor. It wasn't his favorite movie. Think about it. He said, "I'm supposed to be the toy of some white kid." It's sorta degrading. **Did you take a picture of him during that stand-up act when he was wearing the bodysuit?** A line from his own mouth: "I didn't have to give up a thing to get this TV show." And he's standing there with apparently no genitalia. **Do you think he seems ashamed?** No, I don't. You know, a lot of this came at a time when Richard Pryor was thinking about his image: "I'm not going to use the *n*-word again, because it's derogatory. I'm not going to do anything to bring shame to the race and also bring shame to me." So it was—I think he was probably questioning a lot of things he was doing and saying. I took that picture when I took a picture of Richard Pryor for the cover of *Newsweek*. **Did you try to search for his TV show in your map app?** No, I typed it into Google. **That's the map app.** Well. It told me the year his TV show came out.

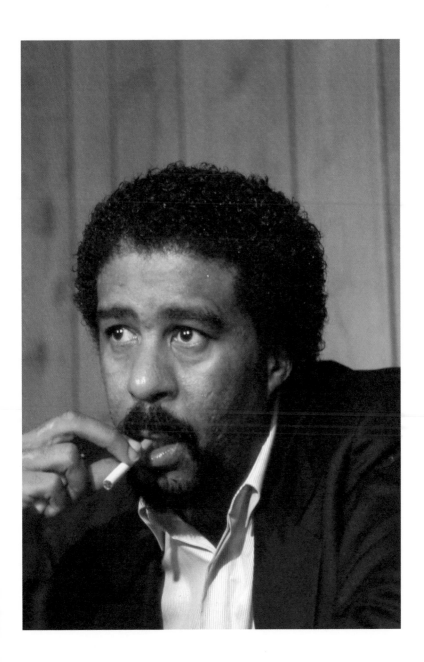

———

Spike Lee. *Get on the Bus*. This was the most interesting story or movie I'd ever seen about the African American male. It didn't start out that way. That film was about a bus trip going to the Million Man March, but it told a story about African American men in a way that hadn't been done before. You had every kind of character in there. And something representing how young Black men sometimes grow up. You had the elder in Ossie Davis, who not only in the movie but in life has always been, became, a spokesperson or the godfather, the grandfather. Ossie Davis was there when—what was her name? the singer Marian Anderson—she sang on the steps of the Lincoln Memorial because she wasn't allowed to sing in Independence Hall. He was there for that and many other important moments in Black history: he was a witness. I know, doing camera setups and what have you, I would sometimes sit with him and he would tell me stories, like about when Malcolm X called him the night before he went to the event where he was killed, and he told Ossie, "They're coming for me. But I'm not going to hide from it." He spoke at Malcolm's funeral. Being on that bus was like living Black history. Because you had every kind of character you wanted to find in a dysfunctional family. And many of these guys in that movie just went on to absolute greatness.

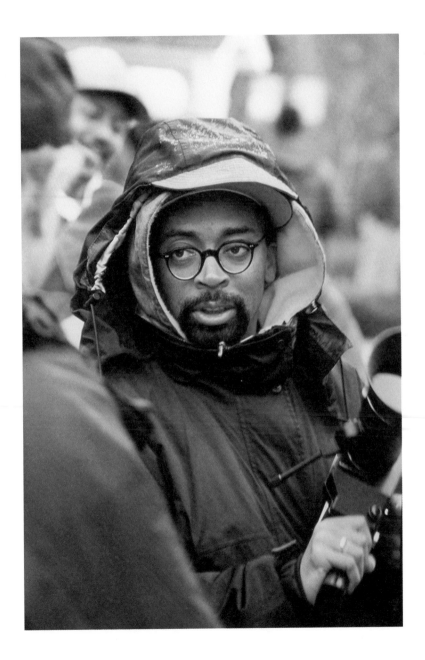

LA UPRISING

———

A lot of times we see things through a prism shaped by what we bring to this image we're seeing. People look at this picture and see a riot. I look at this picture and I know it's people putting out the fires that were set. But since it's a riot-like situation, you sometimes see it through the eyes, through a different prism. In one of James Baldwin's books, he said that his mother said something like "an idea is like a Black piece of velvet." And for years he thought that an idea had something to do with—that's not the exact quote but—an experience he had with his mother talking about how an idea is like a Black piece of velvet or something like that. He said that for years he thought that's what an idea was, a smooth piece of velvet. But there is something elegant about that. **How does that relate to the picture for you?** I guess I can understand why people look at this and think, Oh, that's a riot. But I say, "No, this is someone trying to put out a fire." And they're not trying to put out the fire because they want to go and loot it. They're trying to put out the fire because this is something that's occurring in the neighborhood in which we live. They were angry that the perpetrators who had beat up Rodney King went free. But these people were trying to save their own home. In a way they were saying yes to the anger but no to the destruction of those things we need. Places to shop, places to live. But that's the kind of madness that, when people are mistreated, when there's no justice, at which point you say, "I don't care." How else can you show your rage?

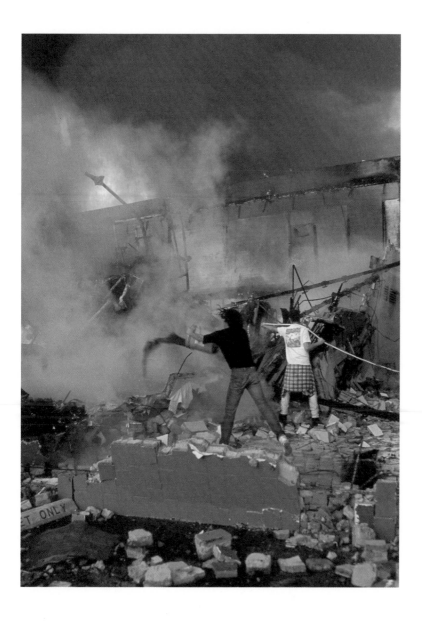

———

Sunset in Hawaii, huh? **Yep.** Sometimes you take a picture simply because it is there. **[*Laughs.*]** I mean, haven't you seen things that are so unusual, so breathtaking? **Was that the first time you went to Hawaii?** I went to Hawaii a couple times. In a way, every time you go, it is the first time. First thing you notice about Hawaii is the smell. As soon as you get off the plane, it smells different. As soon as you walk through the airport and go outside, you know you're in a place that's not only visually different, but it smells different. **What did it smell like?** Flowers. Sweetness in the air that—it could have been the flowers or the fruit or something. It was just: This is as close as you're gonna get to heaven without actually dying and going to heaven. There was something about it; it was another world. It smelled good; it looked good. **Did you go swimming?** I probably got in the water someplace. Not the ocean, probably. I was never a water person, you know. [*Laughs.*] **I thought you used to swim at Belle Isle or something.** I'd go to Belle Isle to go swimming early in the morning. I would run from my mother's house over to the boulevard, out to Belle Isle, go swimming, and come back. **But you weren't really into ocean swimming?** There's a guy named John Carlos—remember the guys holding their fists in the air at the '68 Olympics in Mexico City? John Carlos wanted to be a swimmer. And, I mean, he had gone to the Y and all that, but there weren't a lot of places where Black people could swim in an Olympic-sized swimming pool. But he was excited a few years ago when a Black woman won a swimming competition, because when he was a kid, he had wanted to be a swimmer, and his father had asked him, "Where are you going to go to practice? The

ocean?" So he was sort of adopted, picked up by a cop, who encouraged him to go to track and field, try running, try something else. It was only because he had the chance to go to the pool and practice. But a Black kid in New York? Where are you going to go and do any of this? I was trying to call him when she won the medal, just to talk to him, because that was his dream as a kid. **You're in touch?** Well, I sorta lost touch with him because he's in California and I'm in Detroit. He used to teach. I probably could find him easily, but I just remember seeing that girl get that medal that was his dream. And, actually, he said as much; somebody interviewed him after it happened, and he said as much, that it was always his dream to be an Olympic swimmer but there was nowhere to go to practice.

———

I believe this was on a Navajo reservation. Somewhere along the line, I'd gone to Window Rock, Arizona, and I was told by someone to avoid old medicine men. If they offered to shake hands with you, you shouldn't shake hands, because they could steal your spirit. And I remember my first encounter with an older gentleman, first thing he did was stick his hand out, and I backed up and put my hand in my pocket and he just cracked up. I guess I believed it. That's sort of an embarrassing story about believing the myth, the stories you've been told about people. I got out of that habit. It was sort of insulting. In future encounters, I never did that if someone was extending their hand or I was meeting them for the first time. **Do you remember the story?** The story was just about Native Americans and how they live. It was done at the time we had an editor who said that as long as he was editor of *Newsweek*, there would never be a Native American or Dick Gregory on the cover. He just let it be known how he felt about certain people.

DIDN'T YOU GO TO WINDOW ROCK?

———

This was all Navajo land. **What does this picture say to you?** It's just a reminder of how we treat individuals—people. I mean. It's almost like... who knows. This cow might have died because it ran across the road and got hit by a car. But in a way, to me it symbolizes how we treated the people who lived on this land. **Didn't Mom spend time on a reservation?** Mom had gone to a reservation when she was working with the church. She had gone to Window Rock, Arizona, and worked with Native Americans, and she knew more about that part of the world than I did. **Didn't she get her ear pierced with a piece of straw on a reservation?** I don't know if it was a piece of straw. Whereas I was sort of standoffish, Mom seemed to just meet the culture and the people with an open heart. Because that's the way she is. Rain [*turns to my mother*], didn't you go to Window Rock? *Yeah, I taught summer school at a reservation a mile away from Window Rock. We also went to Gallup, New Mexico. We walked into this bar and two people were facing each other, and everyone in the room was silent. We just walked right out of there. And then we went to Santa Fe. We took the Greyhound from Gallup.* Sounds like a bad movie. *It was a bad movie. My friend picked up this guy and we had to sit three to a seat going back to Detroit.*

ED CLARK

This was taken at Ed Clark's studio in Paris. I don't know when it started, but the French government gave him a space to work. One studio to live in, and one studio to paint in. **How'd you meet?** I met Ed the year Michel Fabre and Henry Louis Gates Jr. had this meeting about the contribution of African Americans, when they dedicated the building with Richard Wright's old apartment to Wright. He was a good friend of Ollie Harrington's, so Ollie introduced me to him, and you go from there. **You would visit him when you went to Paris?** One of the must-stops. It wasn't his paintings that interested me; it was his storytelling. There was as much color in his stories as there was in his paintings. Not only would he tell you what happened, he would set the scene, give you a profile of the people involved. And he'd end a story by saying, "Ollie beat the dog shit outta him." There was a guy, Ollie loaned his apartment to him once while he was traveling in Spain or the South of France. And when he got back he wouldn't give him his apartment, said, "It's mine now." A nice place to live is hard to come by. Especially in the '50s and '60s, when a lot of these guys went back there to live. Remember, Ollie was a journalist as well as an artist who was writing stories about the war, the Second World War. **So what happened to the guy?** Far as I know, he might have died by now. **But what happened when Ollie came back to his apartment?** The guy didn't give the apartment back.

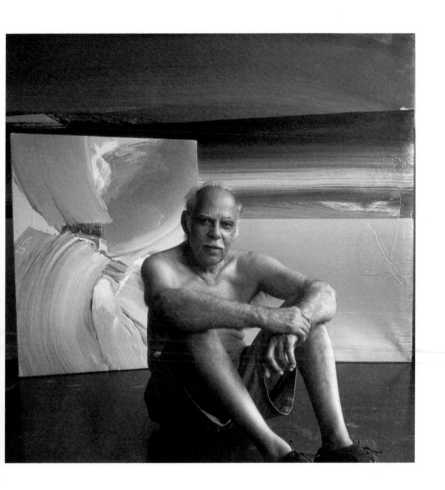

JULIA AND HELEN WRIGHT

———

Very funny. At this conference in '92 that Michel Fabre organized, there was one meeting where different people spoke, and I have it on tape: Julia Wright was talking about her father, Richard, and his work in Paris. And this guy, whose name I'll think of shortly, stood up and said, "Julia, I want you to know that I had nothing to do with your father's death." And there was just absolute silence in the building. Ollie Harrington looked at me and said, "Did you hear what I heard?" Guilt must really have been eating away at this person. One of the things that Ollie talked about was how some Blacks over there got their money by snitching on their friends.

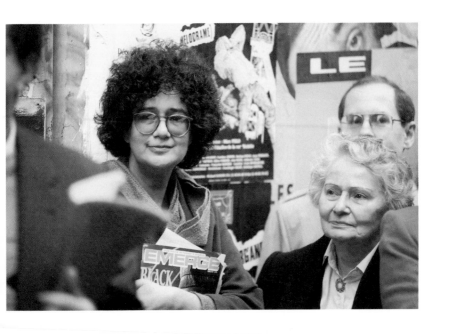

————

There he is. The eyewitness. The bookstore was fascinating and the people we met were equally fascinating. **A lot of people hung out when we were there. Your friend Mary Louise—** Oh, yeah. Well, that place had its characters. You could spend days there, just sitting around reading or talking to people outside. It was just— That little square from the front of the store down the street to where you turn to the right and you go down another street. I love that place. Everybody had a story. Mary Louise, sort of a gypsy lady. **Didn't she live in Italy with her family under a bridge?** Yeah. This was the same person you could take as a model to some fancy hotel and she looked like she'd been doing that her entire life. She was a great performer. Paris was full of them.

THE QUEEN'S TOAST

I remember I was covering the Reagans and we were going to be filming some event where the Queen was speaking, and Wally McNamee, a senior White House photographer who worked in Washington, DC, knew my assignment was to get the Queen's toast as she toasted the Reagans, or get a picture of her, whatever. I was in the pool, and Wally told the British Secret Intelligence Service: "This gentleman here is a member of the White House press corps, and he is positioning himself on the dias on the stage here, off to the right of Reagan and the Queen." **He said this to them and then what?** He wanted to make sure, I mean, he didn't say that for anyone else there. There were several photographers in that pool who were supposed to get this toast. **But what happened when he said that?** The guys said, "Okay, we understand." He just wanted to make sure that there was not going to be any hindrance. Now, I don't think Wally would have had to say that, had I been a white photographer, a white person. People know that if you have a certain credential, you're supposed to be in a certain place. There have been instances where—in Philadelphia, the president was supposed to be shaking hands with—he was going to be at this metro stop. **Reagan?** Reagan, shaking hands with people as they got off the train, and I was rushing with other photographers, going past this police officer who let everybody through, and he put his hand out and said, "You can't. Wait over here." And I said, "No, I'm in the pool," and he just said, "You're not going anywhere. Stay here." I had travel credentials, my *Newsweek* credentials, my Secret Service, everything that everybody else had, but it seems to me that I must have been the wrong color. Now, this paranoia is always with you, and it just so happens that the Secret Service agent

who was responsible for the pool came up and said, "Lester, what are you doing here?" And I said, "This guy," pointing at the police officer, "thinks I have no business being here." And he said, "But you got your credentials. What's the problem?" Anyway, the Secret Service agent went up to the guy and said, "He is a member of the press. If you don't let him through, you're going to be walking a beat for the rest of your career." And the guy pulled back the chain keeping me from going through and let me go. And that was it. The funny thing about it was that this guy, the Secret Service guy, it turned out his last name was Sloan too. We joked the whole time we were together, "Same brother, different mother." It was a joke between us. It wasn't a joke when he talked to the police officer.

WHAT WAS GOING ON

I wonder what was going on there. I forget. You were always so attentive to what was going on.

AN INTERESTING METAPHOR

———

Do you know what a sleeping policeman is? **No.** It's a bump in the road if you're going to a village or something. But they call the bump a sleeping policeman. Which is an interesting metaphor for someone enforcing the law.

DIRTY

———

This was a drug raid. I remember going out on a police raid— **This one?** Well, one like this. One of many. I remember going out on a raid and we were taken to—we were following these drug busters, and we pulled up at this house, they went in, they handcuffed the wife, who was holding her baby, and the grandmother, and they were all handcuffed on the couch. And the son walked in, and said, "What the hell is going on?" And they grabbed him, threw him up against the wall. And the way it was going on, it was obvious they knew about this guy—they more than knew about him; they were using him to show off for the press. **They knew about him and they were putting on a show?** He knew these guys were dirty, the cops were dirty. And they said, "Shut up," threw him against the wall, handcuffs, and the reporter and I said, "Let's get out of here." We just left. Six weeks later there was a bust of cops who were dealing in drugs. **Rampart?** No, not Rampart. This was in South Central. But the cop who had led that raid, the lieutenant, I was told I had to photograph a guy who had turned state's evidence against the police department as a way of getting a lesser charge. And I went to meet this guy. I was supposed to meet him near downtown, at a park there. And I drove up and he said, "Oh, I was hoping they'd send you. How you doing?" And I said, "So what's this all about?" And he said, "Well, what are you going to do when you got two million dollars' worth of drugs?" And I said, "You know, I knew you were rotten the day I met you."

THE LARGER PICTURE

What I took away from this experience is that we are the bulk of people in jail, even in places where you have—where we don't make up that much of the population in the community. **Does it affect the picture at all, now that you have a grandson who is incarcerated?** You know, one of the things I have a hard time dealing with— I told him once, "You know, you may not be totally guilty of what they accused you of, but you were close enough to smell it." And his response sort of shocked me: "Thank you, Granddaddy." He thought I was blowing smoke, and I was just saying, *You're guilty of something.* **But the judge used him as an example.** He had a choice. **In a system that is looking for him to fail.** It's not looking for him to fail. **Yes, it is. I feel like he deserves more big thinking than that. It's part of a bigger picture.** I'm not saying he shouldn't be given credit, but what these guys had going for them and what he had going for him differed. It was a conscious decision on his part. **I get that. It's just not seeing the larger picture.** I think it's seeing the larger picture. I'm not saying that the system isn't screwed up.

GEHRY HOUSE

First time I saw this house I thought of the expression "People who live in glass houses shouldn't throw stones." I thought, Damn, it would be nice to live in this house. This has more to do with the light, and it's the end of the day, the sun has set and all that, and you see different patterns or shapes. **This is Frank Gehry's house?** Yeah, that was when it was under construction. There's another one of him in the house.

FRANK GEHRY

———

You see him in the right-hand corner? **It looks almost like a painting of him hanging in the house.** Yeah, it looks like a portrait of him in the window. **That's what I like about this picture.** I guess this was the beginning of his fame, from Santa Monica to Bilbao. **Didn't you have a good relationship with him?** I told you he said, "If you buy a house in California, I'll do this to your house as well, no charge." Talk about something I should have jumped at. I could have bought a gas station. Talk about a house appreciating in value. He also designed furniture. You ever see it? **No.** Simple. First thing you think: I've never seen anything like that before.

All of a sudden the color of the people in charge changes but not so much the politics. **Was this your first time seeing royalty?** This was the first time I met Prince Charles. I met him again years later when he came to Los Angeles. I also met him when the Queen went on a cruise. I had this thing in the office, everybody from the press corps was invited to meet the Queen aboard the royal yacht *Britannia*. We were told not to engage: "Don't touch the Queen; don't ask her any questions. And speak only if spoken to." So I'm sitting there, waiting on the deck, the Queen comes out, first person she walks up to was me, and "Good afternoon." She extended her hand, asked, "Who do you work for?" I said, "This lady knows how to work a crowd." It told me a little bit about—I learned something about her, which, later in life, when they started making movies about her and her life and what have you, she was a rebel. She went to Africa and asked the president to dance with her. It was like meeting Pope John Paul II.

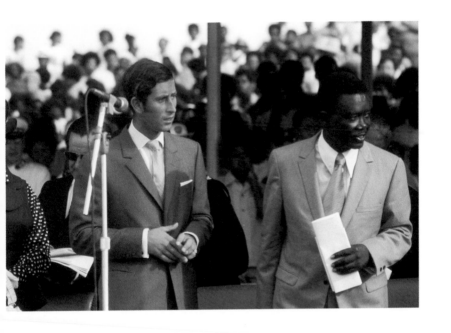

SELMA BURKE

———

I call her the Dime Lady. Strangely enough, the credit goes to the engraver of the dime and not to the artist who did the drawing of Roosevelt. **What's her name?** Selma Burke. Dr. Selma Burke. **When did you meet her?** I would say in the '80s. **Where?** At her home in... look her up. Where did she die? **Pennsylvania.** Right on the border between Pennsylvania and New Jersey, I think. **I feel like you had a story about her.** She just never got the credit she deserved. **Didn't you have a story about walking into her house?** We were outside talking one day and I said, "Can I use your bathroom?" She said, "That cane on the steps, just throw that out of the way. That belongs to—" another woman, a big civil rights lady. The cane belonged to her. **Whom might it have been?** I visited her home, too, in South Carolina. **How big of a person?** Huge. In Black history. **Rosa Parks?** No. There was a school started in her name. **Mary McLeod Bethune?** Yes. She said, "Just kick that cane out of the way. That's Mary's cane." **Because she was there?** She visited one day and she forgot to take her cane with her.

DIME SKETCH

————

You remember Selma Burke showing you the sketch? Oh, yeah. She had made it on—not shelf paper, but some sort of paper she had lying around the house or that she had handy. It wasn't as if it was rolled up in a tube for safekeeping. She just went through some papers or drawings she had and said, "Oh, here it is." **Did she do that portrait in person?** Yeah. **What'd she say about it?** Nothing really. She had a little time to sit with him. It's funny, the person who got the credit was the engraver—the engraver got the credit for the facsimile of Roosevelt on the dime. Which was sort of strange, you know? But that's the art world. One of the things she was angry about: Bill Cosby was buying up art. In fact, I think on his show he had a lot of art by well-known African artists. And there was a guy who was an art dealer and he was gathering up stuff to be in Cosby's collection, but the price of it was that the artist had to give him a painting. I remember Selma Burke was angry. She said, "I'm not going to give you a piece of art," and he said, "Well, it can be in Bill Cosby's collection if you give me something too." What's the guy's name who was friends with James Baldwin? **Beauford Delaney.** I was telling this collector that some friends in Paris were trying to raise money to buy a tombstone for Beauford Delaney's grave because he was in an unmarked grave in France. I knew this guy had pieces of his work because I'd seen it in an exhibition. He said, "If you're trying to raise money for a tombstone, get his agent. His agent made enough money off of him." I said, "Apparently that's been tried." He said, "I haven't got the money"—but he's a millionaire. But that's another story for another time.

MEDITATION

———

Fly fishing is almost like a meditation: it's almost like doing yoga or practicing tai chi. But it looks like one of the most relaxing things in the world to do. If you see the action a fly fisherman makes with his arms and wrists, making the bait go through the air, and if you're lucky enough to see a fish jump out of the water to grab it, the meditation is complete. **Did you ever go fishing?** Yeah. [*Laughs.*] Yep. We used to go to Canada all the time, not to go shopping, but to go fishing. My mother loved fishing; my father could take it or leave it. I used to have my little bamboo pole. When we went fishing, we didn't use rods and reels; we used a bamboo pole with the bait tied to it, and when you got a bite, you felt a tug on the pole, you yanked it up, and if you were lucky you got a fish. You hooked the fish.

JON VOIGHT

———

Jon Voight was strange then and he's stranger now.

VANESSA WILLIAMS'S HUSBAND

———

Bette Midler was sort of a person who grew up around different types of people, and she was very honest and real. Who is the actor, actress, that was Miss America and she became an actress, she started making movies? She was a Black Miss America, or in a Miss America contest. **Vanessa Williams?** Vanessa Williams, yeah. Midler knew Vanessa Williams's husband, and, well, I'll leave it at that. **Why? Why? Well, otherwise all you've said about her is that she was very open and honest.** Well, I mean. **What is the connection to Vanessa Williams's husband?** Well, she was talking about how she was always trying to seduce him and what have you. She was just very real. You know. **Why did that come up with you?** You start talking about people, you know, and I knew Vanessa Williams's husband because he was a friend of Dennis's, and, you know, it's just a small world, especially if you're Black and you become a part of it.

MAGIC

This was actually a very sad day. This was when Magic announced he had AIDS. It was sad. But I saw one of the biggest demonstrations of love and respect, because the person he called after that—I gotta think of the basketball player's name now—he played for Boston, but he came out and said, "This is the saddest day of my life, and I'm going to stand by my friend no matter what. Hopefully, he'll get over this." And I remember instead they ran a picture of him in short briefs, pants or something, lying on a bed. And that was the cover. **Lying on a bed?** I'll tell you what a female editor of *Newsweek* said when they ran a story of him lying on a bed. The editor called me up and said, "Sorry about your cover. The only thing I can say is you can call it 'white boy penis envy.'" In other words, they were trying to say he was gay because he was lounging on the bed. **That's not what I see when I look it up. There is a picture of him that says "Even Me."** What does he have on? [*I show him a black-and-white cover photo of Johnson, shirtless, holding a ball.*] Is that the whole cover? **What do you mean?** I remember a different... **I think this is the cover.** That's not the picture I remember. **Why do you think you have a different picture in your memory? Could there have been another one inside the issue?** It's possible. **Is it possible there was something about this picture that still frustrated you?** It wasn't because they killed my cover: that's not it. But there's something about the cover that... **Like, because he's not wearing a shirt?** Maybe so. But I actually remember—I don't even remember a basketball being in his hand. But I vividly remember the editor's remark. **I don't think this is the same day. Wait, actually, there is a date on the slide. Let me look it up. This is the day he became the head coach of the Lakers.** Oh, all right.

BRUNO BETTELHEIM

———

I guess this is one of the most misunderstood people in the world. **Why do you say "misunderstood"?** He thought, I'm sure, that his research was valid, but he had a lot of mothers feeling like they were responsible for their children's abnormal birth or behavior. **You don't think he deserves that reputation?** It was bad science. His critics said that it was just bad science. And I know a couple people who had children and they felt guilt even when it was revealed that this guy was wrong. Made me wonder what kind of relationship he had with his mother. **What was his research, exactly?** Basically, that women who had autistic children, it was because of their lack of attention to the baby. But he was crazy about his daughter and his granddaughter; they were all living in the same house. He committed suicide. **So he may have been a bit haunted by his past actions?** Haunted to the extent that he took his own life.

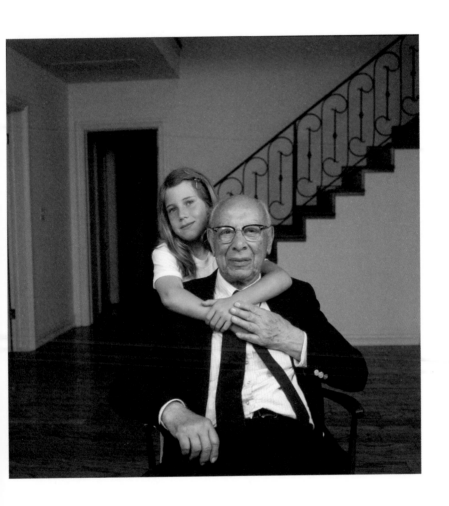

PAUL WILLIAMS'S WIDOW

———

This is the widow and granddaughter of a famous Black architect, Paul Williams, who was known as "the architect to the stars" because he built Frank Sinatra's house, he built a number of people's houses, he built the Beverly Hills Hotel. This is sorta like in California, Los Angeles; this was like the upper class of African Americans. This is her birthday party, Paul's wife's birthday party. **You were covering it?** No, I was invited by the granddaughter to cover it. If *Newsweek* wanted a picture, then fine. **Did they?** No, they didn't. **Was *Newsweek* interested in covering that kind of event?** No, *Newsweek* would not be interested in it. **Why?** With Ed Kosner as the editor at the time, this was not a picture that was ever going to run. *Newsweek* **seems to have been very interested in photographs of poor Black people. But not of well-to-do and even famous Black people having a birthday party. That seems interesting to me. That seems important.** Well, okay. If they were interested in doing a story about the husband of this lady here, they might show an interest, but either you had to be famous or famous in the eyes of a New Yorker. **But what would have happened if more white people had seen photographs of Black people having birthday parties?** There have been *Newsweek* pictures of Black people celebrating something, but usually the person had to be famous. It's hard to believe, but this particular architect used to—he learned how to draw upside down because he knew if he was showing someone an idea that he had for something, that it wasn't going to work for him to lean over their shoulder to do this, so he had to do it upside down. It showed his dexterity and his knowledge of sketching, or his ability to sketch from upside down, something

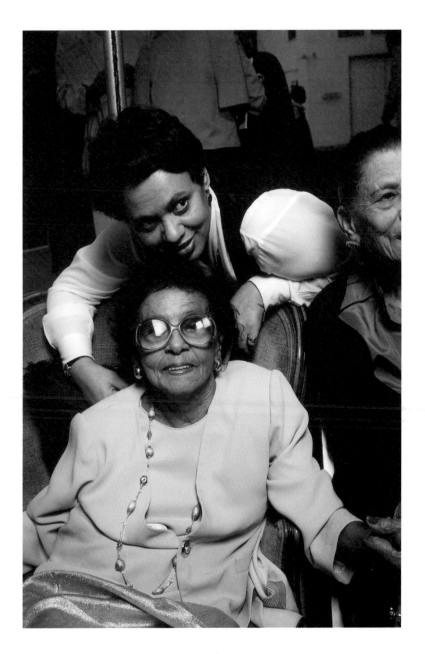

upside down. But it also prevented him having to say *Excuse me* to a person who might not want you standing over him. He talked about how difficult it was working in a white world, even if you were world renowned.

HIS OWN
PRIVATE DIASPORA

by Aisha Sabatini Sloan

WHILE HE WAS at *Newsweek*, my father came very close to being trans-
ferred to the Paris bureau. A move was put into the works, then over-
ruled. One of his white colleagues, when asked, claimed she worried
the French would treat him poorly because he was Black, which she lat-
er admitted was a lie, costing him the job. He never really got over it.

Perhaps because he wasn't able to move abroad, over the years
he has recorded dozens of conversations with members of the
African diaspora. It's a hobby. He interviewed Afro Germans soon
after the poet Audre Lorde came to Berlin and encouraged young
people in that community to seek one another out. He spoke with the
actor Marpessa Dawn, who moved to France as a teenager and starred
in the Academy Award–winning film *Black Orpheus*. He climbed five
floors to visit the poet James Emanuel, pioneer of the "jazz haiku," in
his Paris walkup. Sometimes this hobby overlapped with our family
trips. Our vacation videos, which might begin with a shot of me as
a toddler riding a carousel, would invariably cut to a half hour–long
conversation with a young man from Martinique who had made the
innocent mistake of disembarking from his motorcycle in front of
my father. We probably made our way to the Eiffel Tower or the
Trevi Fountain—I honestly can't remember—but what I can recall
is a trip to Italy in the early '90s during which we visited a freckled
woman named Daniella, a Black ballerina who had danced with
Rudolf Nureyev in the late '80s and lived with two gigantic black
dogs and an apple orchard in Assisi. The stories he has collected, the

lives he recites over and over again like a mantra or epic poem, are iterations of paths his life might have taken. As if by knowing them, he gets to live them all.

Al Thomas was an opera singer. I remember sitting on his rooftop patio in the early '90s—and it was strewn with vines—as the sounds of Rome's traffic buzzed pleasantly below. In the staticky VHS tape I recently digitized, Thomas wears sunglasses and a white sport jacket with an Italian soccer patch on the shoulder. He toured in the '50s with the Everyman Opera Company, performing *Porgy and Bess* in countries ranging from Russia to Venezuela, a cultural exchange funded by the US State Department and the Soviet Union with the express aim of softening the tensions of the Cold War. A young Maya Angelou was part of the cast. Truman Capote wrote about the Everyman Opera Company after traveling with them to Saint Petersburg in a 1956 piece for the *New Yorker* called "Porgy and Bess in Russia." Thomas told my father he was annoyed at Capote for largely ignoring the Black cast and for crafting, instead, an entertaining travelogue about the wardrobe and the chitchat of the wealthy white wives who had come along—Leonore Gershwin and Wilva Breen. Capote does a fine job of recounting the dissonance and, sometimes, the outright racism inflecting interactions between the cast and their Russian audience. He notes, with humor, how the Russians expressed their feelings about capitalism in their treatment of the cast and crew—the Astoria Hotel "had arrived at their system of room distribution by consulting Everyman Opera's payroll: 'The less you get, the more they give you.'"

In one of few observations about the cast, Capote describes a moment with Rhoda Boggs, who played the Strawberry Woman, and whose name sent Thomas into a nostalgic swoon. Capote encounters Boggs after she has attended an Evangelical Baptist church service

in Russia, "her little Sunday-best hat was slightly askew and the handkerchief she kept dabbing at her eyes was wet as a washcloth." Boggs told Capote, "The pastor, a sweet old man, he asked the interpreter to ask us colored people would we render a spiritual, and they listened so quiet, all those rows and rows and rows of old faces just looking at us." She describes their departure: "They took out white handkerchiefs and waved them in the air. And they sang 'God Be with You Till We Meet Again.' With their own words. The tears were just pouring down our faces, them and ours. Oh, child, it churned me up. I'm all tore to pieces."

In my father's recording, he asks how Thomas feels about leaving the struggle of Black life in the United States. Thomas is remorseful. He recalls the stories he heard as a child from elders who fought in the Civil War and wonders who will pass these tales on to his many nieces and nephews. At the same time, he recalls the limitations that sent him searching for freedom abroad. He explains that a white man, down on his luck on Skid Row, can put on a suit and get whatever life he wants. He's got it made. But for a Black man in America, "We can put on all kinds of suits. We ain't got nothin' made." He voices these words as though summoning a character from *Porgy and Bess*, a deviation from his otherwise near-Shakespearean manner of expression. It is difficult to imagine that this openly gay opera singer, whose apartment overlooked an ancient city, would have found the same level of artistic or spiritual fulfillment had he stayed at home.

In the mid-'90s, on a different trip, my father took me with him on a visit to the home of the writer and sculptor Barbara Chase-Riboud. I recall a parkside apartment imbued with elegance, bringing to mind the impossibly fashionable Black American singer in the film *Diva*, who strolls through the Luxembourg Gardens during the blue

hour of twilight with a gold umbrella in the rain. Chase-Riboud was born in Philadelphia in 1939. She sold a woodcut to the Museum of Modern Art when she was fifteen years old. After she received a bachelor of fine arts from Temple University the following year, she studied at the American Academy in Rome. Early in her artistic life, Chase-Riboud encountered freedom fighters and Black Panthers at a pan-African festival in postcolonial Algiers, where, she said, "a kind of historical current brought all these people together in a context that was not only political but artistic."

The accident of history and its aesthetic implications inform Chase-Riboud's work in a variety of wildly inventive ways. She is a poet as well as a sculptor and a novelist, the author of eight books in all, and has long written historical fiction that goes to the heart of race and gender oppression in America and Europe. In two of her books, *Hottentot Venus* (2003) and *Sally Hemmings* (1979), she imagines the interior lives of Sarah Baartman—sometimes known as the Hottentot Venus, a Khoekhoe woman from South Africa who was put on display in nineteenth-century England and France—and Sally Hemmings, the enslaved woman who endured a long-term relationship with her owner, Thomas Jefferson. These elaborate tomes bring a desperately needed interiority to the lives of Black historical figures, much in the way that John Keene, through his short-story collection *Counternarratives* (2016), reendows the lives of the enslaved with an intelligence and imagination that have an almost architectural complexity—vast, ornate halls of vision, ideation, and feeling. In my father's video of her, Chase-Riboud says this of leaving the country: "You discover that America is not the center of the world. It may be the most powerful, but it's not the center of the world and it never will be. So this kind of frees your mind to think of other things."

* * *

One summer, my father ended up visiting with the poet James Emanuel, who, like Richard Wright, found inspiration in Japanese poetry. His visits to Europe morphed into a permanent exile after the death of his son, also named James. The young man had been badly beaten by the police, who mistook his book satchel for a weapon; soon after, he died by suicide. Emanuel writes that the news of his son's death "pinned me against the kitchen wall. I remember, my arms stretched high, clutching at it as if I were trying to climb over it." In one poem, "Deadly James (For All the Victims of Police Brutality)," Emanuel visualizes his son as a child in the Brooklyn rain: "Your arms and lips and laughter reaching up / for all the sky could pour / upon the rivers capering inside you." Emanuel, who was born in Nebraska, vowed never to return to America.

Another artist whom my father visited frequently while abroad in the '80s and '90s was the abstract painter Ed Clark, who was born in New Orleans in 1926 and began living in Paris in the 1950s. In an online video, Clark describes how the Hungarian landlord of his Paris studio cut a skylight into the roof when he wished, aloud, for light. "Suddenly," he said, "I could paint." While in Paris, Clark began to create paintings with a giant broom, calling to mind the 1942 Gordon Parks photograph *American Gothic*, in which a Black American woman named Ella Watson stands in front of an American flag, holding a mop and a broom. Clark repurposes the broom, symbolically breaking out of the role America prescribed for him. Clark's movement away from the United States blew open new approaches to the canvas. The critic Geoffrey Jacques described in one exhibition catalog Clark's use of colors—most often pink, blue, and green—as "fields of *turbulent luminosity*." Clark translated the spiritual landscape of his life into bolts of glowing pastel.

* * *

Ollie Harrington was a political cartoonist, who, like my grandfather, first came to Europe during World War II as a correspondent for the Pittsburgh *Courier*. Harrington observed that many Black veterans incited fear in white Americans, who seemed to realize, after the fact, that it was a mistake to train Black soldiers to kill whites in war. In his 1993 book, *Why I Left America and Other Essays*, Harrington refers to white America through a colloquialism for Uncle Sam: "Sam himself had diligently trained Black youngsters to use rifles, machine-guns and flamethrowers. Some had even flown fighter planes and bombing planes. But what really bugged the judges, sheriffs and southern senators was that these Black soldiers had aimed their contrivances with evil intent at white men!" This realization spawned, as Harrington points out, a new spate of lynchings.

Harrington and my father were close friends. My father took me out of elementary school in the middle of the year when Harrington came back to the States, and we flew to Ohio for one of his lectures so I could meet him. Though he did not call himself a Communist, Harrington was sympathetic to Communist causes, and critical of America's uneven application of democratic values, which is evident in his audacious political cartoons. He attempted to settle back home in Harlem after the war but was warned by a friend in Army intelligence that he was under investigation, so, in the 1950s, he moved to France. In a 1970 conversation with John Williams, the novelist Chester Himes describes Harrington as follows: "Ollie was the center of the American community on the Left Bank in Paris, white and Black, and he was the greatest Lothario in the history of the whole Latin Quarter. And he was a fabulous raconteur, too. He used to keep people spellbound for hours. So they collected there

because of Ollie. Then the rest of us came." Harrington was, according to Richard Wright's daughter Julia, Wright's last best friend.

In his work, Harrington documented the damage done by American racism to many of the Blacks he befriended abroad, who could not be healed simply by moving away. He recounts an anecdote about a Black veteran he calls Harris. Harris had allegedly been shot in the war by a white American soldier. He couldn't see the difference between the ss and his white compatriots, so he decided he'd rather not return to the United States. Inspired by the artists around him, Harris took a drawing class. But when the white female model disrobed, he ran out of the class without his supplies. Another Black expat, the painter Herb Gentry, recalled the scene teasingly: Harris "thought the rednecks had finally trapped him." But the incident was evidence of deeper turmoil. In another instance, Harrington noticed Harris weeping at a bar after he'd found himself incapable of returning the advances of a white Frenchwoman, so debilitated was he by fear that the interracial romance would be punished by death. This dynamic is illustrated in one of Harrington's cartoons, which shows a boat captained by two Black men, approached by a pair of white mermaids. One character says to the other, "Look, man, I don't need you to tell me that they're only mermaids. An' I also happen to know that they got blonde hair, blue eyes, an' we're only three miles off the coast of South Carolina."

Harrington told my dad that one could earn a fast fifty bucks by going to the American embassy and telling them who had been at the last party they attended. Once, Harrington lent a Black novelist named Richard Gibson his apartment while he visited friends in the South of France. When Harrington returned, Gibson refused to vacate the apartment. Gibson went on to write letters critical of the French government and signed Harrington's name, which would have led to Harrington's deportation if Gibson had not been found

out. According to Ed Clark, Harrington "beat the dog shit out of him." Richard Wright wrote a version of this in his unpublished novel "Island of Hallucination," in which a Gibson-type character appears as a spy. When, in 2005, the National Archives released documents about the assassination of John F. Kennedy, it was revealed that Gibson had, in fact, been paid nine hundred dollars a month by the CIA. For Harrington, the story didn't end there. One of the essays in his autobiographical collection is titled "The Mysterious Death of Richard Wright." Harrington leaves the reader to wonder about the possibility of foul play in the death of his otherwise-healthy friend. The circumstances of Wright's death were so terrifying to Harrington that he moved to East Berlin, where he spent the remainder of his life. The last time we went to Paris, we found Ollie's old apartment. My father, while standing in the middle of the street, repeatedly reenacted the moment when Harrington called the hospital to learn of Wright's passing.

During a trip to Saint-Paul de Vence in 1990, my father met a painter who introduced him to a friend of the family of James Baldwin, who had died in 1987. My father was left alone for hours to photograph Baldwin's still-furnished home, where the beds were made, the mantel was adorned with mementos, and papers were scattered across the author's desk. When I look at the images he took that day, I see a new dimension of my father's transnational desire, as if he were finally able to wander around inside the life he longed to inhabit.

I call my father to ask, "Did you know that Richard Gibson was a spy?" And he bellows enthusiastically, *"Of course I did,"* laughter undergirding his tone, as if he's been waiting all these years for me to feel, in my bones, the significance of the stories he's been telling. Ollie Harrington used to watch an epiphany dawn on my father's face

during their hours-long conversations. "There you go," Ollie would say, watching my father's eyes flash in sudden understanding of one of Harrington's loaded silences. In all the years he's been imparting these stories, my father has been hoping for me to experience a similar set of epiphanies—to realize, especially, the value of the lives he has recorded, the imprint they've made on history.

In the videotape of my father's interview with Al Thomas, my father's young voice asks, "You were saying earlier, when I arrived, you would like to see more Black people come abroad. To what end? Besides seeing the wonderful pleasures?" Thomas thinks it over and replies, "In some way, it will help us to preserve some of our own culture for posterity, don't you think?"

ABOUT PAUL ROBESON

———

You know, I got to know some of these people pretty well. There was one young lady who was a drug user and she was also a mom, but she was really trying to clean up and lead a normal life, and she had never gone to a see a play or anything like that. She'd seen movies. There was a production—I have to remember what production—there was a one-man show in Philly that I got tickets to, and I said, "Look, I'm going to take you to see this show." And it was the first time she had ever seen a play. **Do you remember what it was about?** I'll think of—I think it was a one-man show about Paul Robeson. It was a famous actor portraying Robeson.

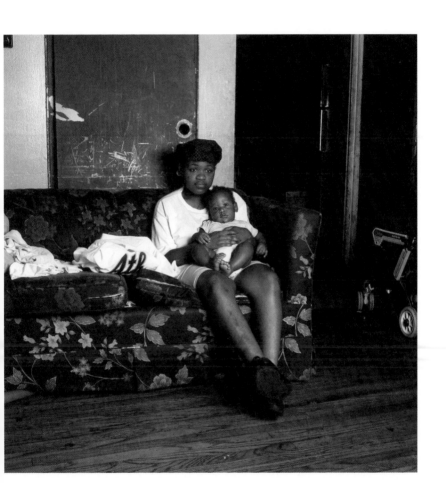

FLO JO

———

Well, when I look at this picture of Flo Jo, I think of Evelyn Ashford, who was the sprinter that was expecting to make history because she was just—she had slowly but surely come along. You know, by the time Flo Jo died, everybody was convinced—or not everybody, but people were talking about how she had used drugs, enhanced... This is when a lot of athletes, mostly male, had been guilty of using drugs that would enhance their performance. And I remember a race where Evelyn Ashford was in it and Flo Jo just ran away from her, and the look on Ashford's face: it was the saddest thing I've ever seen, because she knew, and every other athlete knew, that in order to take three-tenths of a second off of your time in a sprint, it would take a whole lot of timing and focus and what have you, and it's something that you sort of work up to slowly. And they knew that Flo Jo was probably using drugs. **What if she wasn't and she won?** Well, okay, if she didn't, she didn't. But athletes know how much work is involved to take off x number of—one-tenth of a second, two-tenths of a second, that's what you're talking about in sprinting, and you just don't do it overnight. **I have this memory of doing the stadium stairs at UCLA and seeing Flo Jo. Do you remember that? We would go there to exercise?** Yeah, we would go to UCLA and run the bleachers. **Didn't we see her there?** We saw quite a few athletes. I'm trying to remember who else we saw out there. Edwin Moses: he was one of the big Olympic winners. A lot of long-distance runners, especially women, worked out at UCLA. I remember one of the middle-distance athletes from an Eastern European country, she invited me to come over, she said, "Bring your wife!" She said, "We'll kill a pig in your honor."

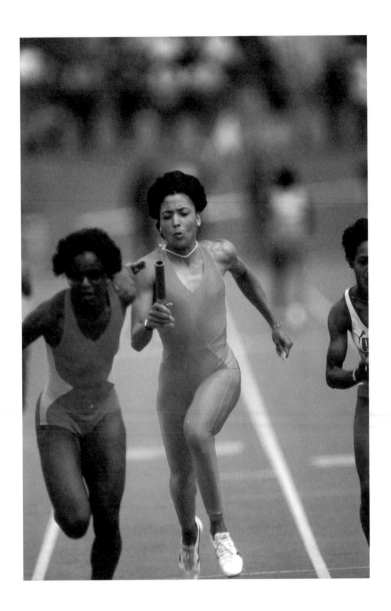

———

It was beautiful to see this. **Is it the LA River?** No, this is inland somewhere, where—it had to do with bringing water to farmland. **Kind of like a Diebenkorn.** It's just a striking image. Water has always been an issue in California. They had to bring water in from the Central Valley and what have you, there was a movie made about water in California. ***Chinatown?*** *Chinatown*, yeah. You know it? **No.** It's funny, when I found this picture I was thinking that water has always been an issue in this part of the world. There was an oil man named T. Boone Pickens. And I think in the '90s or maybe before then, he got out of the oil business and he started buying water rights. And the first question you ask yourself is, How can you buy the rights to water? I mean, it's the same thing as selling sunshine.

AN NFL STAR

This was Food from the 'Hood? I just remember that as being sort of an interesting experiment with kids, most of whom grew up thinking groceries came from a store. They didn't grow up on a farm, weren't familiar with farming. And you could see they were excited about doing what they were doing. Especially when they saw it on the supermarket shelves, the product they'd produced and all that. Oftentimes kids don't learn about working together in a group to accomplish a goal unless it has to do with sports in school. But here they did something together. The main thing was excitement and willingness to work. People were buying their products. I remember the two kids who appeared on the cover: the young man went on to become an NFL star. I spoke to the woman responsible for the program last year, and, unfortunately, he had injuries and was in bad health, too many licks to the head. But, by and large, a lot of these kids, some of them went to college. Besides learning something about farming, they learned about themselves, working together on a project and seeing something come of it. **Did you ever spend time on a farm?** No. My mother always had a garden. There were always peaches and apples and stuff growing in the backyard. I had spent time on my grandparents' farm, but not farming; I was too young for that. I remember falling into the pigpen and my grandmother wrestling a pig to the ground because the pig thought I was going after one of her babies, and hogs are pretty big. And my grandmother sort of jumped, got in the pigpen, and jumped on the back of this pig and wrestled it to the ground.

A STUDY OF LINES

On the road to Palm Springs. Power grid. **It's a cool study of lines.**
It's also an implication of these lines bringing electricity, and elec-
tricity brings light. It's almost as if the power from the light coming
from below is coming to the wires above. **Like the sunset?** Yeah.
**There's something about the color that allows you to see how
pretty the lines are.** Yeah. **Did you expect to be in California for
so long?** No. Before that it was always living abroad. Everything
I had done pointed in that direction. That's where I wanted to be.
One of the women who led the strike at *Newsweek* said, "You should
quit and move to France. You've got a foothold in some of these
places. You've gotten as much as you're gonna get out of *Newsweek*."
Newsweek allowed me to go out and sample a world that I wanted to
be a part of. Eventually I started to find a greater interest in people
and in places I was living. Going to the coffee shop around the corner.
I found out I could be in those places just by meeting people who
had lived elsewhere. The world existed where you found yourself.

———

This is back in the late '70s, when people went to Mexico to get drugs they couldn't get in the States, in some cases because they couldn't afford them, in some cases because they weren't made. Mom used to take your grandmother to Tijuana to buy what she needed for arthritis because it wasn't sold in the States. But there was a time when people were flocking to Mexico to buy that which they couldn't buy in the States. Some of it they say was no good and some of it was fine. **So you went with them?** I went there to do a story about a drug they were selling to cancer patients. **It's an emotionally potent picture.** I just see hope realized. That's all I see is hope realized. That they have— they're looking forward to getting that which they couldn't get at home. It told a story in one photograph. All the names are Hispanic names: they're all Hispanic doctors. These are various Americans. Those who are seeking, those who deliver.

TIJUANA

———

Apparently one of his customers was John Travolta. The picture implies that one of the jackets he makes, John Travolta is wearing.

BORDER SURRENDER

———

One night I went riding with the—what do you call it? Border Patrol. **What was happening in this picture?** This was people coming to work. **Do you remember any details about it?** You were allowed to ride along with the patrol as they were out rounding up people crossing the border at night. **What were they like, the Border Patrol?** They wanted us there; they were very friendly, very nice. This was something they wanted to photograph. **Okay.** Where they happened to catch people depended on where and how they were arrested. If you were downtown in the Garment District, they would arrest you and send you back. If you lived in Brentwood and were walking a baby, you were left alone because you were illegal, but nobody was going to mess with you. White people hired illegal aliens. Nobody ever stopped Hispanic ladies pushing white babies around. **This is a very powerful and disturbing photograph. What can you tell me because you were there?** Truthfully, I was pissed off that I was part of it. I was pissed off that I was being used to—this was a photo op that the Border Patrol wanted to have. *See what we're doing, catching these people?* I didn't feel good about being there.

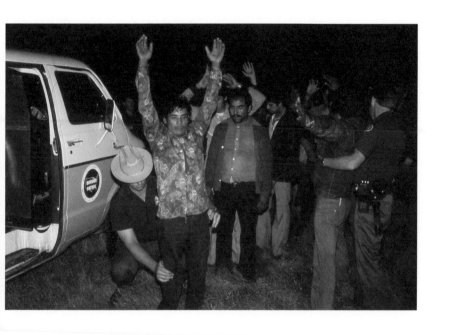

COMPLICIT

————

Can you talk about the picture? How does it make you feel to look at it? Shame. I feel ashamed. I feel bad that people are treated so poorly both in the country they're fleeing and in the country they're fleeing to. I feel bad, I'm angry. But I'm doing my job. This picture here simply tells part of the story. **You feel complicit?** It's more like I feel ashamed. I feel like this is happening to you because you look different. Because someone has labeled you as an undesirable. My god, people who leave, Europeans who leave a Communist country, are welcomed with open arms. What the hell does it feel like to be driven to the point where you're going to be hunted down by a person with a camera and told you have no right to be there, you gotta go back? White people wanna get out of a situation that's bad for them, and they can make it to America; it's a sanctuary. I don't want this to sound like I'm angry— **About what?** It's not much different than... Being Hispanic and seeing how some of these people are treated, it's just a reminder to me about where I stand. **Yeah.** I just happen to have a piece of paper in my hand saying I'm allowed to be here. But I go home and somebody who's pissed off because of something he's seen on TV can arrest me and say, "Why are you driving this car?" "It's a rental car. Because I work for *Newsweek* and they say I can rent a car?" "Let me see your papers for the car." "Why am I being stopped?" "You look suspicious." If you take pictures like this and they don't make you feel guilty or complicit in this farce, then there's something wrong with you. There are places where I show up and I'm treated the same way. Just depends on how fast I can prove that I'm something "other than." If a cop can pull into my garage, pull in behind me and tell me to get out of the car and ask me, "What are you doing here?" "I live

here?" And then your neighbor who lives next door to you can get out of her car and walk right by you like she doesn't even know you. And the next day you have to see her and explain what happened. **Who?** An older lady who lived upstairs. **She babysat me.** Yeah, I know she did. **So she suspected you of doing something wrong?** When she got out of her car, I was parked right next to where she had parked her car. She walked straight: she didn't say, *Lester, is anything wrong? Lester, are you okay? Lester? Lester?* I didn't stop speaking to her, but I guess she assumed that if they stop you, you've done something wrong.

NANCY REAGAN

———

I guess Nancy Reagan created programs for children with developmental disabilities. You know, Betty Ford, the one who pardoned Richard Nixon, Gerald Ford, she was a person who—she called attention to a disability that she had related to alcohol or drugs, and worked toward helping people who had the same thing. She lived it and she did it because it was the kind of person she was. Nancy Reagan was here because this is what first wives do: they pick something they can lend their support to. Nancy Reagan was a very nasty person. **Okay, that's interesting.** And the idea of her doing something like this—she gets kudos for doing it, but her heart's not in it. I've been around Nancy Reagan when it was her and her husband. She talked to him like he was a stupid puppy.

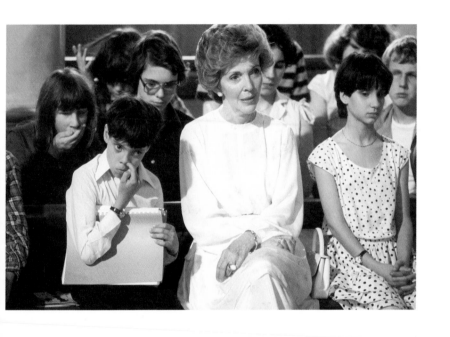

MICHAEL JACKSON

———

Michael was a great mime. Who is it he's mimicking here? Is it Chaplin? Charlie Chaplin? **Looks like it.** That was his favorite actor. He could do that crazy walk he had with his cane. Michael was a genius. But, I mean. He was quite a character. Moonwalking was something that—I'll think of the singer's name. Michael wasn't the first one to do it.

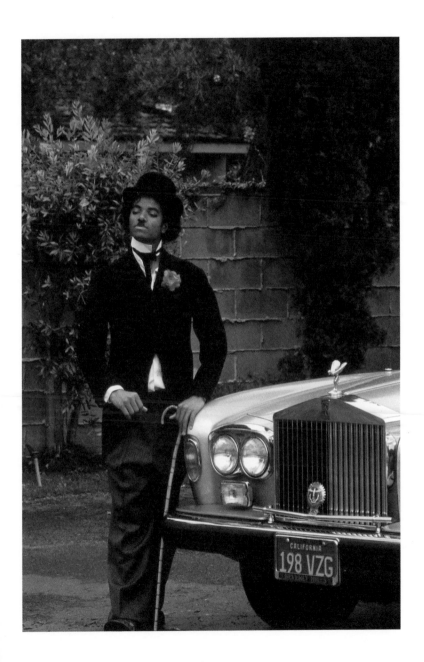

NOT FROM NATURE

———

Where were you? Out in the woods. There's some places in Hollywood Hills you can come to where you can find a setting like this. It's so peaceful and—just quiet joy, just being there. **Did you go camping a lot? Or hiking?** Not as much as I would have liked to. I didn't belong to the Boy Scouts or the Cub Scouts as a kid, and usually that's the way you had a chance to go out in nature and what have you. I understand people who like camping now, and every chance they get they're off someplace to be in the woods, to be alone. **When I went camping, you drove around the mountain all night. Remember?** Were we lost? **No, you were trying to protect us.** I know that. Not from nature.

THREE THINGS

There was a volcanic crater in Maui that you could actually hike across, and one of the things I wanted to do—three things I wanted to do—I wanted to hike the Grand Canyon, and I wanted to hike across the volcanic crater in Maui. **What was the third thing?** I think it was going on a cruise to see the glaciers in Alaska. But I figured: low, high, and then cold. I ended up hiking the Grand Canyon twice, the first time with food poisoning, didn't know it till I got down to the bottom, barely got back. **Did you cross the crater?** No, I never got around to going across the crater. **You still have two big goals.** Things to do, oh yeah. **All right, let's put those on the list.** When you went to Alaska I thought, Oh, that would be a great chance to go and see the icebergs.

STEVIE WONDER

———

How many Grammys has Stevie Wonder won? **It looks like…
twenty-two?** I think he's won more than any other individual.
What's your favorite song? "Isn't She Beautiful"? Singing about his
daughter Aisha. **"Isn't She Lovely"?** "Isn't She Lovely," yeah. **Was
I named after that song?** We discovered it around the same time.

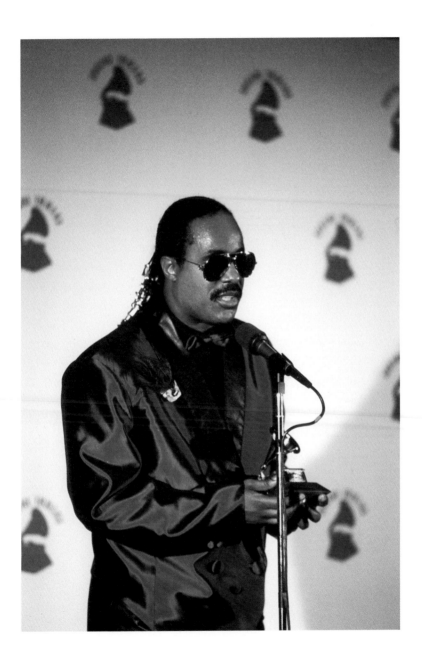

DIONNE WARWICK

———

Dionne Warwick. The woman who made Burt Bacharach a million-aire. He'd like to think its's the other way around. She was probably, or is, one of the nicest famous people I've ever met. I used to play tennis with her husband, and I remember he invited all the tennis players over to his house one day. They were having a party for Dionne Warwick—not Dionne Warwick... This is so crazy—the Supremes, the leader of the Supremes. You know, very slim singer, she became a diva herself. She, uh, lives in Europe now. **Diana Ross?** Diana Ross, yeah. Diana Ross was there at the party. She was sitting across from me, and I said, "We have a mutual friend," and she looked at me as if to say, *How is that possible?* and she said, "We have a mutual friend?" And I said, "Yes." I said, "John MacDonald." She said, "I don't know John MacDonald." And I said, "I bet you remember Pudgy." And she got really quiet and she said, "Oh, yes. Uh, we're good friends." And I remember the hostess looking at her and smiling and sorta laughing about it, because I guess the last person she expected to meet at a party for one of her close friends was someone who knew her when she was dating Rodney's younger brother.

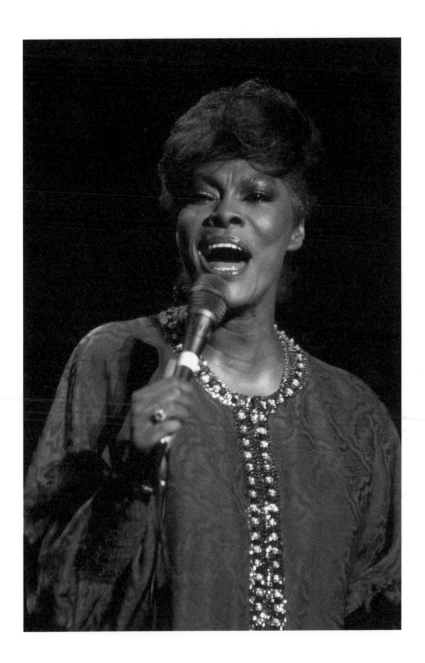

FILM STILL

——

Remind me who this is? This is Stokely Carmichael. Not Stokely Carmichael. The Black Panther. Huey Newton. **What's the story?** Actually, he was being interviewed by a colleague about a book he'd just come out with. The mainstream media had an almost romantic relationship with the Black Panthers. I was reminded of this later on. I went to a party at the home of a photographer friend, and at the party were Eldridge Cleaver and his wife, and a renowned photographer. And the vice president of *Newsweek* magazine. And they were all sitting there, laughing, talking, passing a joint around. And I remember saying to the host off to the side, I said, "Vice president of *Newsweek*? Eldridge Cleaver? Nobody would believe this." He said, "That's why you can't take any pictures of it." **Have you ever seen the *Kitchen Table Series*? By Carrie Mae Weems? This picture reminds me of that. The woman smoking.** Elisabeth Coleman was her name. She was a *Newsweek* correspondent. **But don't you think that's interesting, that choice you made to have her fingers in the picture?** Ideally, you'd shoot over her shoulder or shoot from the side, but her presence there is—the fingers say enough. **It makes the image more intimate, like it's less of a news story and more of a private moment. What do you think this picture, including Coleman in this way—how does that change the frame of what you're covering?** It goes from being an icon to being... Just a regular guy. Looking at the *Kitchen Table Series*, it's like the photographer faded into the woodwork. **Well, these are staged. She's not documenting something; she's creating something.** The only thing missing is dialogue. **That's what I think of your picture.** That's quite a compliment. **It's like a film still.** Well, that it is. So

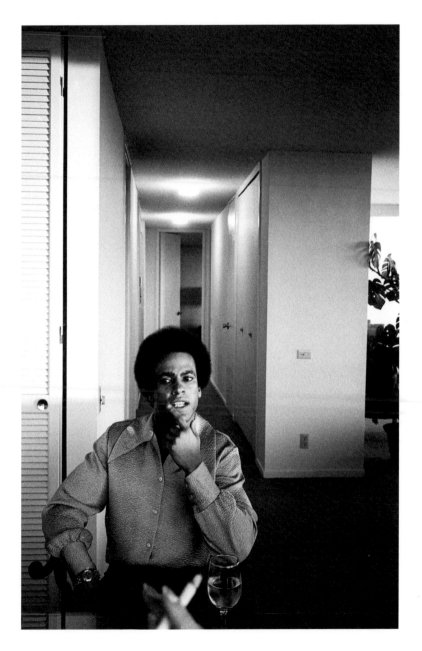

collectively, if those photos are part of a filmstrip, does the sequence have a beginning, a middle, and an end? **I don't know. It's almost like you create the sequence in your head. You create the movie.** Or the viewer, how you arrange the shots—what you show first and second—collectively tells the story. **Yeah. It makes the story kind of infinite.** Hopefully the story continues.

BAHAMAS BUS STOP

———

This feels filmic. You've captured them in the story of their lives. Now, this is a stolen moment here, but there's a lot of truth. They're not—they have a life, and something's going on with them, and that's apparent. It could be a scene from their life. Unrehearsed. They're not waiting for a bus; they're not waiting for someone to pick them up. But they are waiting. **That's your movie of what's happening.** Yeah.

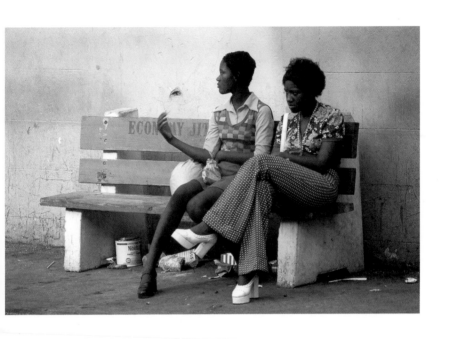

WANDERING AROUND EVERYWHERE

Do you remember wandering around in churches in the Bahamas? I remember wandering around everywhere. Most of these pictures had very little to do with an assignment, I mean. **Was it summer or winter? Was it hot?** It was hot. Most important garment was a hat to keep the sun off your head. This was before I had ever gone anywhere out of the country. This was my first trip out of the country, going to places like Mexico, Guatemala, Nicaragua, what have you. It was all new to me. Prior to that, the only foreign country I'd been to was Canada, and Canada was so much a part of our life that I didn't consider it a foreign country. I wish now that I had gone back to some of these places, not on assignment. Just to spend time, get to know people better, get to know them.

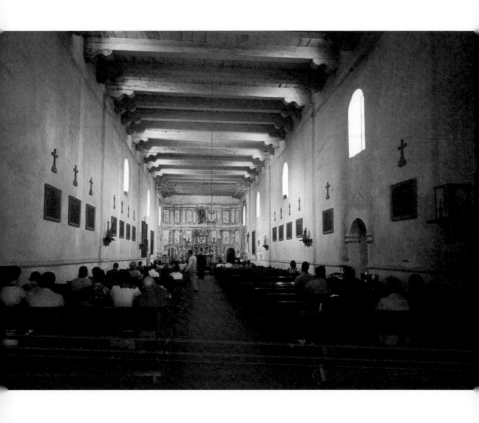

SARAJEVO

Isn't that something? **It doesn't even look like people.** But on closer inspection, you can see that they are. **So you got there, and you stayed with a family?** I went there a year before the Olympics to photograph the preparations for the Winter Games. I arrived in Split, a city on the Mediterranean, I guess. I had taken a boat from Venice to Split, but I was told there was no train from Split, I had to go to the next station. There was this woman there, she asked me, "Are you having a problem?" I said, "Yes, I am. I have to take a bus to go to this town from which I have to take a train to go to Sarajevo." She said, "I live in this town. I'll show you how to take a bus to get there." We went together, and we arrived at midnight. But the train didn't leave until the next day. She said, "I called my mother and you can stay at my parents' house." I said, "Are you sure that's all right?" She said yes. I said, "This is weird." We walked from the bus station to where her mother, her parents, lived. Her mother met us at the door. She welcomed us. She showed me, "This is your room, you can sleep here." I said, "Are you sure this is okay?" I remember in Venice, I asked somebody there, "What can I take with me to give as a gift for kindness and generosity?" And they said coffee, any kind of coffee you can bring. So I got two two-pound packages of coffee, and I had them in my bag. The next morning when I got up, I'm walking in the yard and all that, the mother said, "It's time for breakfast." I went to my room and got the coffee and said, "This is for you." She said, "So much?" I said, "Thank you for your kindness." It was like I'd given them two bags of gold, they were so thankful for it. The father, you know, we talked and he said, "Whenever you come here, you must come back." Anyway, the daughter took me around

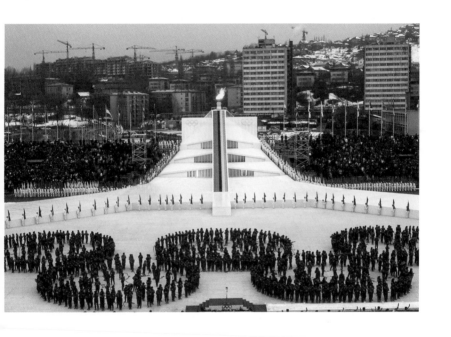

the town to show me a few sites, and we walked to the train station, and I went back and went on to Sarajevo. The father said, "Whenever you're here, this is your home." I was almost crying with gratitude. "When are you coming home? *Wann kommst du nach Hause?*" **Did you keep in touch with them?** I was planning on going back, but then the war broke out. I had met a guy from Yugoslavia and we were going to go back together, but it wasn't safe to go back anymore. I never heard from them again. I know the city where they lived was bombed. A lot of people were killed. That much I found out from my Yugoslavian friend, who didn't go back either. But. Four pounds of coffee and I got adopted.

HE CAME TO DETROIT

———

Every time I see a few pictures I shot of Mandela, I kick myself for not going to South Africa when he was released from prison. I should have just paid my way to go. I'm sure if they realized I had taken the picture, *Newsweek* would have paid for it, but they didn't know it at the time. I thought it was interesting he came to Detroit. This was, as far as Black heroes were concerned, this was a world-renowned Black hero. Think about it: you get out of jail, after being in for no good reason, you get out of jail, and then get elected president.

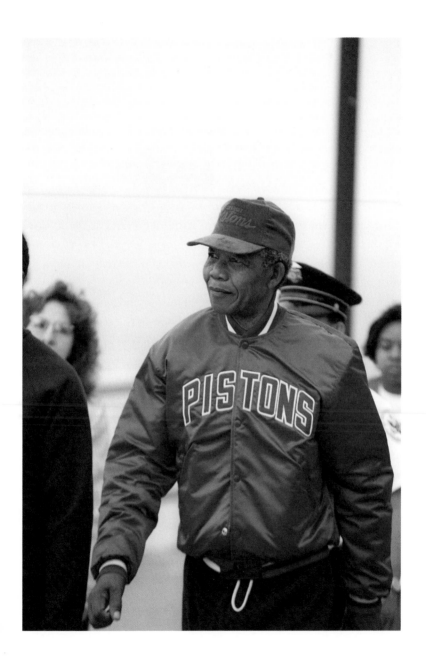

1967

————

It's funny. I remember asking this kid what was his name, and he just walked away. **Well, yeah.** I understood why. But. That was the beginning. **Or the middle.** Well, I mean. It was pretty much the beginning of a career. One I hadn't anticipated. Or didn't think was possible. **Oh, I meant, like, the middle of civil disobedience.** There was a riot in Detroit in 1936 where a number of Blacks were killed by whites, and, I don't know, twenty years later I would meet an old man who was in Detroit when that riot started. He ran a bar for the Mafia in Black Bottom. And after it happened, the guy that he worked for suggested he go out to Hollywood and see a friend of his out there and maybe he'd get some work in the movies. And the rest is interesting history. **Who was it?** Bill Walker was his name. He went to Hollywood and he ran a few clubs in LA, but eventually he got a job in the movies. **Weren't you with Lisa [Lester's daughter] when the riots started?** When they started, yeah. I saw smoke coming from over on Twelfth Street. We were down at Wayne State University. We were actually at the library, over that way, and I took her to my mother's house.

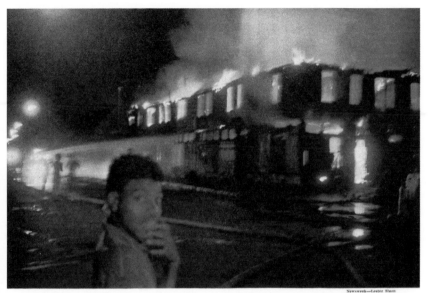

A flaming warehouse on Detroit's East Side burns down to the ground, as a youngster, briefly distracted from the fiery spectacle, uneasily anticipates arrival of the police.

Fires obliterated entire blocks. Harassed by snipers, fighting too many blazes, in too many places, the fire department failed to reach many burning buildings.

ON IMMOLATION

by Aisha Sabatini Sloan

FOR A PERIOD of time in 2014, I couldn't stop watching the sur-
veillance video of a person setting fire to the Heidelberg Project, a
world-renowned art installation by Tyree Guyton in a residential area
of Detroit. The recorded arson struck me as a performance piece in
itself. In what appears to be the very early hours of the morning, a
figure approaches the threshold of a structure called "Taxi House," a
home adorned with boards of wood that have been painted with yel-
low, pink, green, and white vehicles labeled TAXI. There is a painted
clock, real tires, and toy cars. A meandering peach-colored line has
been painted along a sagging corner of the roof, then it comes down
onto the siding, where it moves geometrically, like Pac-Man.

The installation as a whole is like a painting brought to life, im-
bued with the spirits of Kea Tawana, Jean-Michel Basquiat, and Rob-
ert Rauschenberg. In a 2019 profile in the *New York Times Magazine*,
Guyton describes how he began the installation with his grandfather
as an act of reinvention rooted in nostalgia. Author M. H. Miller
describes the collection of carefully planned assemblages as "an act
of Proustian reclamation, as if Guyton were creating a new neighbor-
hood out of the one he'd lost, embellishing his and Grandpa Mackey's
memories out of the wreckage that surrounded them." In the video of
the fire that destroys "Taxi House," the figure holds something that
resembles a gallon of milk, and after a short time, a fireball blooms
out, and the figure runs away.

The Heidelberg installation has the vibe of Plato's lost city of
Atlantis, the mythic civilization that sank into the ocean overnight
after its people lost their sense of virtue. It also brings to mind

Jason deCaires Taylor's undersea sculptures, human figures engaged in activities like typing, playing the cello, or watching TV; concrete bodies surrounded by schools of fish. What's so remarkable about Guyton's effort is that he's constructed a frame around the present moment. The collapse he draws our eye to is not a myth or a dream of the future; it's now.

In the beginning, Guyton experienced plenty of pushback from the city, but the installation has come to be a point of pride. Though Guyton had originally hoped the installation would be a solution to the neighborhood's plight, the traffic it brings (around two hundred thousand people a year) also serves as a reminder of the tension inherent to a city undergoing gentrification. In a book written about the project, *Connecting the Dots: Tyree Guyton's Heidelberg Project*, one neighbor explains, "Every summer night we've got people riding up and down looking at what we're doing. It's an invasion of privacy. They look at us like we're animals on display."

From what I can tell, no motive ever emerged for the arson, and no arrests were made. The one person who checked in to an emergency room for severe burns on the day of the fire had been trying to deep-fry a turkey. More fires have been set at the installation in the years since.

Guyton exhibits widely and has a fan base overseas. Recently, he decided to take the Heidelberg Project down. According to M. H. Miller, Guyton and his wife plan to "transform the buildings that still stand into a series of cultural and educational centers dedicated to the arts, and then build housing and work spaces marketed for artists out of this central core."

As buildings around the country were set on fire in the aftermath of George Floyd's murder, I thought about the Heidelberg arsonist. Widely dispersed memes featuring the Martin Luther King Jr. quote "A riot is the language of the unheard" have encouraged more and more people to see fire in the context of social upheaval—not merely

as an act of destruction, but as an act of ritualized desecration. What language looks like at wit's end. A kind of screaming.

So what did we learn in the wake of the Heidelberg blaze? For one thing, the firefighters who came to put out the fire were delayed because none of the hydrants in the area were working due to widespread water shutoffs across the city. But also, the fire begs some of the same questions that Guyton's work elicited when he first began in the 1980s: Who is the artist? Who is the criminal? Who is the bystander? Who is the institution? Can you occupy more than one role at once?

The first photograph my father took for *Newsweek* magazine was of the 1967 uprising in Detroit. In the image, a young man looks toward the camera as a warehouse burns bright orange behind him under a dark night sky. My father likes to point out how he caught the boy in a moment of bewilderment, of total awe. Recently, I asked my dad to take my wife and me to the place the image was taken. My mother came along too.

My dad begins the journey by veering into oncoming traffic, because the street has gone two-lane, due to a street construction project that has turned the neighborhood into an obstacle course. As we make our way down East Grand Boulevard, a painted storefront next to Flamin' Moez Soul Food reads US AND THEM. The grandiosity of what my parents call "the Boulevard" clears, and now we are passing grassy fields. We are taking a detour from our detour toward another detour.

We drive past the Packard plant, which has become a kind of unofficial graffiti museum. The British artist Banksy consecrated the space a few years back with a painting of a Black boy in a strange black suit holding a can of red paint, next to the message, I REMEMBER WHEN ALL THIS WAS TREES. I can't say I get it, given that the

area is and has long been surrounded by overgrown lots. Banksy's arrival prompted a minor controversy when local gallerists removed the section of concrete he'd spray-painted and sold it for over one hundred thousand dollars. A bit farther down the block, a huge sign promises: COMING SOON! PACKARD PLANT BREWERY. I think about the way that ruin is being involved, here, in a kind of transaction. The image that comes to mind is Goya's painting of Saturn devouring his son.

We pass a public art installation featuring white figures kneeling. On Woodward, a billboard shows a Black cop with his arms crossed and it reads: ANSWERING THE TOUGHEST CALL. Later, we will find out that the night before, Detroit cops, "fearing they were under fire," drove into a crowd of protesters.

Our plan is to first find the site of the Algiers Motel, where a group of police and National Guardsmen killed three people and tortured several others in the midst of the 1967 uprising. My mom says, "On the map it looks like an empty field." Up a ways, there is a sizable gathering of Black men on the steps of a church, with signs that say, GOD BLESS OUR FATHERS. Black men and boys are holding their hands in the air in surrender or praise.

The site of the motel is now a well-cared-for park, gated, mostly empty, and surrounded by brick walls. We pause, then turn back into traffic.

Next we attempt to find the place where my father took the photograph that began his career. After getting caught in a loop in a fancy neighborhood, and circling a beautiful garden where a white man in a fedora appears to be considering purchasing the property, we make a wrong turn. My mother says she's going to call Rodney, my father's best friend, which is a euphemism for "We're lost."

At a red light we find ourselves staring at the bottom of a toppled SUV. It takes a moment to decipher the car's undercarriage, a desert-colored thing resting at an odd angle. At the intersection,

people are streaming across the street like liquid, despite oncoming cars, toward what we now understand to be an accident, endangering themselves in the effort to find out what's going on. I peer more closely into the window of the toppled car but can't make anything out. A man holding a baby keeps darting toward it. There are fire trucks and a police car, city officials wearing masks and looking at the vehicle, but no one is touching anything. The plan of action seems to be hanging still in the air.

I request that we end the tour. I'm not sure what meaning we can make of the site of a long-ago fire when this emergency is unfolding in real time.

On the way back home, my wife and I tune in to the end of an episode of *This American Life.* The story is about a community leader in Detroit who recently hosted a pancake breakfast, putting cops in conversation with the communities they are meant to protect. He talks about bringing people into difficult conversation with one another across the city. The breakfast took place just as the coronavirus was beginning to spread, and afterward several people became ill.

It takes us both by surprise to realize that the man whose voice we've been listening to, Marlowe Stoudamire, just died of COVID-19. On the show, many lament that he would have been a natural leader in the protests against police brutality that sprang up shortly after his death. Voices attempt to describe him, only to break. His wife tells the story of watching him tear up on a recent family vacation to the site of the Coliseum, a place he'd never expected to see in his lifetime.

My wife and I don't talk much for the rest of the day. Not until debriefing each other that night do we realize we've both spent the last few hours replaying the scene of that horrible accident, replaying the moment we realized that Stoudamire was dead. Even though

we're inundated with bad news all day, every day, there is a weird relief in the specificity of this sadness.

Later, I look up Stoudamire to see what else of his story I've missed. He was the director of an exhibition for the Detroit Historical Society called *Detroit 67: Looking Back to Move Forward*. The project features a wide swath of voices that collectively tell the story of the Detroit Rebellion of 1967. There are hundreds of collected oral histories. One woman recalls walking around with her father on mornings after nights of unrest. He would take photographs as they processed what they saw. Another woman, a professor of anthropology, talks about how the uprising reminded her of the time she spent studying in the Middle East, and compares the situation to the Arab-Israeli War, which took place that same year. A man who served on the National Guard says there are things he saw during his deployment at the uprising, things the police did, that he'd rather not share. The fact that he is being invited to revisit a memory that he'd like to keep to himself gives the whole project a new kind of valence for me. It reminds me of the Truth and Reconciliation Commission.

In reflecting on his career, my father talks about how he often had to argue with white editors who saw the Black subjects of his photographs as criminals and perpetrators. Meanwhile, when he looks at the photo he took of the boy and the burning building, my father sees a bystander, an innocent person. He is trying to defend the young man from an accusatory, racialized gaze. But lately I've wondered how else to interpret what's captured there. What if he did set the fire? What might he have been trying to say? On the Solange song "Mad," which has served as a much-needed balm for Black listeners since 2016, Lil Wayne says, "Now tell 'em why you mad, son."

During his interview for *Detroit 67*, Marlowe Stoudamire said, "It's important that nobody gets their story left out."

MACABRE

This was never a part of the work that I enjoyed. Going to crime scenes. **Yeah.** But I did a lot of this working the night shift at a television station. It's not pretty. **Everyone looks like they're in shock.** Pumpkin, what was under that blanket was shocking. And, you know, first responders get to a point where they have this sort of macabre sense of humor. They make jokes that are not funny, and they say things that are absolutely horrendous, but they do it because they're trying to pretend it doesn't bother them. You see so much of it that you have this sick sense of humor. I remember once going to a scene like this where the officer is looking over the body of someone who'd been smashed up in a car accident, and the guy looked at me and said, "You all done?" I said, "Yeah." He said, "Let's go get breakfast." He laughed when he said it, but I realized this was his way of saying, *You get used to this*. In fact, you never get used to it. Or it depends on what you mean when you say "used to this."

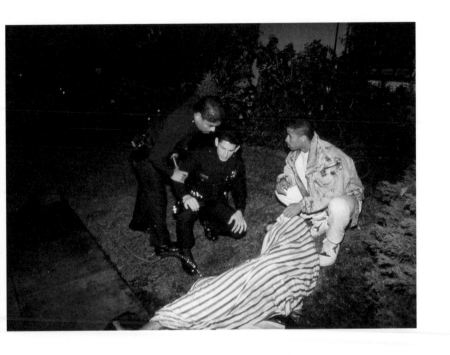

MAXINE WATERS

This is after the Rodney King verdict. Maxine was also very active in pointing out that the people who brought the drugs into the community didn't live in the community. **The police?** In some cases, the police. The big drug dealers lived in Brentwood, Hollywood, all those well-to-do places. There was a guy I knew that was dealing drugs, and he talked a few times about the places he went to pick up stuff; he said it wasn't in the 'hood. Actually, the kids who wanted to buy drugs, the white kids, came to the Black community to do so. **Could you have imagined Maxine Waters would become such an icon?** Oh, yeah. **Was she iconic even then?** Even then she was iconic. Maxine is just, she didn't need anybody to teach her. She's just a feisty, hardworking, knowledgeable person about what's going on in her community. She was never at a distance. She never became so big that she didn't go out among her constituents. If Maxine was on your side, then you had somebody who was going to try to do something to help you.

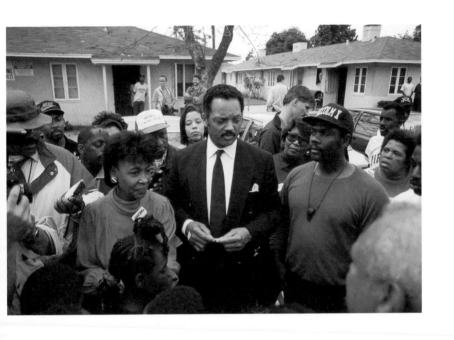

CABO SAN LUCAS

———

Light, color, and sunshine. **Was this a travel assignment?** I wasn't on assignment for *Newsweek*; I was on assignment for LaVetta Forbes. **The magazine she had?** Yeah. The interior of some of these hotels is also colorful. They were always frequented by rich white people. I was always surprised by how few Blacks you saw in some of these resort places. **Do you like taking architectural pictures?** I do. Architectural photography is really quite challenging. **Didn't you and Mom go to Mexico for a cruise?** We went on a cruise, yeah. We got in a habit—instead of going with the guide, we would take off on our own. The guides would take you places where you could spend money, they counted on you spending money. What you could discover on your own was much more exciting than what the guides were going to take you to.

ILLUMINATED FACES

———

I mean, you couldn't have orchestrated a better picture. It looks like they're in the headlights of cars themselves. The picture begged to be taken. The setup is wonderful, them posing in the headlights of other cars. **When you say looking in the headlights…** It looks like they are looking into the glare of oncoming cars. They are caught up in the low beams. It's very smart. I didn't suggest it; it's the way they lit themselves. And it was just perfect. I happened to be in the neighborhood that night. It was just such a great picture, I wanted to take it. It's about the car. The lights say the car is in the foreground shedding light on them.

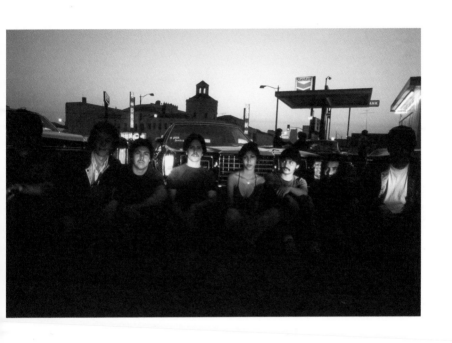

THE LADY IN BLACK

———

I like this one. I love this picture. So the lady in black: Is she the Mother Superior or what? **You tell me.** That's what I assume. She's the oldest. And I think the black is an indication of rank or something. As well as age. **She has very kind eyes.** There's a welcoming smile; all of them are smiling, even the lady on the left. Despite herself, she's smiling. The lady next to the Mother Superior, she looks like she's about to break into a strong giggle.

———

The Mama of Dada. **When did you meet her, the Mama of Dada?** I'm not sure how I met her; seems like I was on an assignment. She was connected to a famous photographer. I'm trying to think of the photographer's name. It was one of the guys from France. Who were some of the artists connected to the Dada movement? **Duchamp? Was it that one guy with the creepy pictures?** Yeah, they were creepy pictures, but who was he? **Man Ray?** Yes. **I thought that was the woman in France.** That was a lot of women in a lot of places. **So how did you get connected to her?** I think I had gone up to Santa Barbara. Was it Santa Barbara where she lived? **Ojai.** Ojai, all right. **What do you remember about that visit?** That she—she must have been ninety years old then, somewhere approaching one hundred. And she was a notorious flirt. She was quite funny. And I remember that some of the people who worked for her were sort of suspicious of me. She was "Here, come sit next to me. Come." She was just very bold and flirtatious. But warm and cuddly at the same time. There was something genuine about her that was sort of disarming. I remember that a couple of the people that worked for her wanted to cut my visit short, and she said, "No, no, he's gonna have lunch with us, he's staying." And I went back on more than one occasion. It got to the point that whenever I was going to that part of California, I would always manage to stop in to say hello to her.

ZUBIN MEHTA

Zubin Mehta, right? I remember photographing him several times in several different places. He was very picturesque when he was engaged in his music. He was almost as much fun to watch as it was to hear what was being played. **Anything unique you remember about him or photographing him?** He was as interesting to talk to as he was to photograph. Even when he was relaxed, he's such a photogenic person to begin with. You can very easily see flames of light coming from his eyes. Even when he's relaxed, that same energy was there, reflected in his body language. **Flames? Why flames?** You ever see a brush fire? **Mm-hmm.** Well, I mean, you can feel the energy: it's a hot energy coming from his eyes, his body, his fingers, everything. Flames come to mind. Fire comes to mind, heat comes to mind, energy comes to mind. Possession: He's possessed by the music and the moment and what he's doing. It's all focused.

ONLY ONE IN A SUIT

———

This is my favorite Beatle here. Not Beatle. **Favorite Rolling Stone?** Rolling Stone. I'm sure it was in Cabo San Lucas, where he got married. This was funny: I had instructions to meet him on one of the main streets in Cabo. And I was sitting down on a park bench or something and he walked up to me and said, "You must be Lester." And I said, "What, did they say I'd be the only Black there?" And he said, "No, they said you'd be the only one wearing a suit." That told me a lot about the people I worked with who thought a photographer should look like Animal on *The Mary Tyler Moore Show*. Was it Animal? The photographer on *The Mary Tyler Moore Show* with Lou Grant? Anyway, I thought it was funny, and so did he. I was taken with this guy because he seemed more down-to-earth than the so-called star of the group. And the fact that they're about to celebrate their fiftieth wedding anniversary is some testament to that.

LAURA DERN

———

I always thought of her as being Daddy's girl, but after seeing this movie, I realized she had become quite an accomplished person. I mean actress. If she was ever in Daddy's shadow. **What movie?** The movie we saw the other night. Where I ate too much popcorn. *Little Women.* Wasn't she in *Jurassic Park?* Yes. She was just one of the young actresses out there then. *Jurassic Park* came out later. *Blue Velvet* **came out that year.** Who starred in that? Laura Dern. **Also Isabella Rossellini. You have a story about her.** Who? **Isabella. Don't you have a story about her?** Wasn't she married to the famous director? **That was her mom.** You ever hear the story Gordon Parks told about that? He was sent to photograph them. **What happened?** Just about every photographer at *Life* magazine and *Look* magazine, a number of photographers are trying to get a private moment with them together. And they sent Parks to Italy, where they were making a film, some island where they were doing a shoot. And Parks had asked for an opportunity to photograph them and they'd never said yes or no. One day she was going over some lines or something like that, the director was reading something, he stuck his hand out, leaning over a piece of paper, and she grabbed his hand, one of these moments when they forgot there was a third person in the room. Parks had his camera and put it down; he didn't want to give the impression that he was trying to steal an image. Apparently, she saw him put his camera away. Later that evening she called him and said, "We're going for a walk tomorrow morning along the beach. Why don't you come along with us and bring your camera?" They trusted him and respected him, and because he didn't betray that trust, sneak and do whatever the paparazzi were trying

to do, he succeeded in getting an image. Actually, the image they ran had nothing to do with them being together. It was her and the women in the village looking at her like she was a vamp. I never told you that story? **I just watched the video of Gordon Parks telling you that story.**

What is there to say about Anita Baker? She was a great performer, a great singer. **It's not just about her; it's about the picture or taking the picture.** There's some people who can sing, and you're all caught up with the sound, but Anita Baker—when she performed, you felt like she was feeling every note she wrote; every gesture she made somehow contributed to the sound that was coming out of her. She was wonderful: That's a smile of joy on her face. And you feel the joy when you listen to her and when you see her, because it's hard to take a bad picture of her. **I feel like her album was always playing when I was growing up. Her music reminds me a lot of childhood.** Why? **It was playing all the time.** [*Laughs.*] Really? **Yeah.** Only time I got angry with her was when I found out she tore down an historic house on Jefferson to build a pancake house. But, you know. I guess she said it wasn't her history.

A YOUNG GENIUS

John Singleton was a young genius. This was on the set of *Boyz n the Hood*. I was doing a story for *Emerge* magazine about casting, a Black casting director. Singleton, when he first got started thinking about being a director, used to work for Reuben Cannon, the casting director. He was sort of the person who nurtured him; he said he knew he was something special when he met him. And he didn't disappoint. **What exactly did you say?** I sent a picture from the session I did with him to *Newsweek*. I said, "This guy's going to be big. He's doing this movie," this, that, and the other, and they ran it and patted themselves on the back for running it, and patted me on the back for running it. It says something about the industry, or publishing, or *Newsweek*: this was somebody they ran a story about before he got famous, and they could sit around and say, "We discovered John Singleton."

VENICE

I guess I gave my camera to someone and said, "Take a picture of me." **Carnival?** Could have been Carnival time, yeah. Venice is both frightening and beautiful. I would get up early in the morning and go out where they were bringing stuff in for the outdoor markets, and, the first day I did it, the first couple days, people looked at me with a great deal of suspicion, because ordinarily you don't have tourists out at that hour taking pictures. On the third day someone looked at me and made a face, pointed at themselves as if to say, *Take my picture.* People greeted me. The fourth day, they see me coming, they wave me over and give me a cup of coffee. That was—I had become a part of them. And I was just a guy. Sometimes people saw me coming, they grabbed each other, put their arms around each other, made a face, threw something in the air: they became performers. It was all their way of saying, *You're one of us now. Welcome.* It's easy after you get past being looked upon as a tourist; sometimes people start taking you as a local simply because you're there every day, you get on the same boat, go to the same restaurant to have coffee or lunch. It's a nice place, an easy place to become a regular.

CIRCUMNAVIGATE

———

I don't know how I happened upon this guy. I heard there was a sailor who had circumnavigated the world, and he came to Detroit to give a talk. I arranged to meet him at Belle Isle or on the river somewhere. I remember telling the story to someone, that he was the first Black person to circumnavigate the world, and only the second or third person in the world to do so, and the person asked me, "How did he get back?" And I said, "By boat." And he said "Cruise line?" And I said, "Yeah." Then I said, "Circumnavigated. There and back." And he said, "Oh, okay." I gave you his name, didn't I? **Captain Bill Pinkney?** Yep.

THE MOOR OF VENICE

Spencer Haywood on a gondola. [*Laughs.*] They called him the what now? They called him the Moor of Venice. From *Othello*. Not *Othello*. Yeah, *Othello*. **And he seemed happy there?** Happy? It was—at first he was not happy because he had been traded away or sold to a team. He was playing with the Lakers, and it seems he had a drug problem at the time and it'd gotten so bad he was falling asleep during practice. He got traded away, and at first he was angry. But he sort of found himself there. **In Italy?** In Venice in particular. He was married to Iman at the time, and she was doing a lot of work modeling in Milan. Actually, the owner of the team let him use the private jet to see his wife. He couldn't walk outside anywhere without people coming around. People in stores would come out bearing gifts, giving him things to wear, clothing items. There was a famous restaurant there in Venice called Harry's Bar. He had his own table there. And the table would seat maybe three or four people, but it was his table only. The table was always reserved. A year after I met him there, he had left, and I went to do a story about this group of kids going to Venice, because during Carnival they were honoring the city of New York, and I went to this restaurant one day, and the maître d' recognized me from the times I'd been there with Spencer. And he gave me his table.

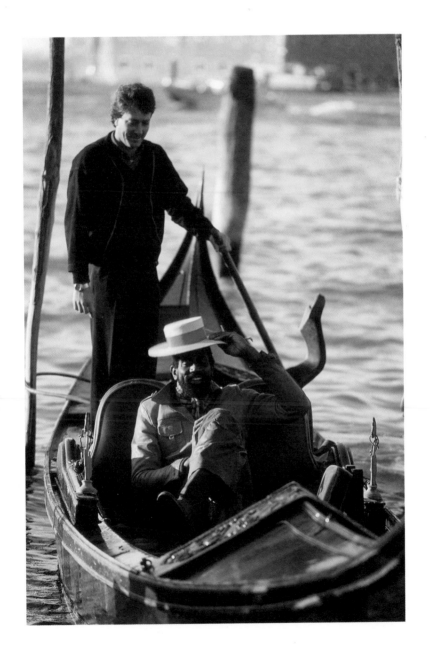

A SOFT FACE

———

What's her name again? Supreme Court justice? **Sandra Day O'Connor.** Sort of a soft picture, isn't it. **Yeah.** She was a nice lady. This picture was her in her office. Arizona. Phoenix was the hottest place I've ever been. I stayed at a hotel within walking distance of her office, and I remember walking across the street and my feet getting stuck in the tar, it was so hot. Actually, I sort of—a mild trot across the street. I'd never been in a place so hot. It's not the kind of hot you have in Michigan. It's dry heat. **What do you mean, it's a "soft picture"?** Not pinpoint sharp. Look at her eyebrows. When you see the cheekbone right under her left eye. Actually, it's not a lack of sharpness. Her face looks like it's been worked with, to remove all the wrinkles. **She has a very particular face.**

THE END OF CAMELOT

Everybody hoped he was going to be the—not only the next president, following his brother, but he just fell from grace. Sort of like the end of Camelot. The other brothers came along and they were all either killed or committed suicide. This one here committed suicide. I don't mean he killed himself; I mean political suicide. You know the story, I mean. He was out with a girlfriend, the car ran over—anyway, she drowned. **Wait, wait, wait. The car did what?** The car ended up in a lake. She drowned. The girlfriend drowned. And he left the scene and didn't report what had happened. **See, I keep trying to tell you that you would like the show _Succession_, but you don't listen.** Well, his career went downhill because he lied about the woman's death, and that was the beginning of the end for him politically. But, see, there's a lot about the Kennedys that... the Kennedys were popular with the press because they were such a beautiful, such a beautiful story. I used to ask, "Why must we go with Kennedy to church every Sunday and report on that, and yet we know that when he goes to this place or that place, he's met at the hotel downtown by Angie Dickinson or Marilyn Monroe or whoever?"

WALTER MONDALE

———

He's the first presidential candidate who had a woman running as vice president. And a lot of people acknowledged that she was smarter than he was. I just thought this was a great picture because Mondale would go anywhere to win a voter over. A guy's out fishing and he stops to chat with him. **What was he like?** He was a nice man, you know. He wasn't like a Kennedy or Obama, who was a great speaker; he didn't get people excited with his message or his delivery, but he was a good man.

ASSASSINATION

I remember when I was sent to Guatemala, I was told to talk to a priest there because he was working with the people, helping them fight against the authorities and helping them lead a normal life. I remember going to this church and asking to see the priest. They said he wasn't around and to come back another time. Whenever I went back, I got the same story. Finally, instead of going directly to the church, I went to where the priest lived and left my business card, with the name of the hotel where I was staying, because the nun who took my card said, "I'll give him this and he'll get back to you." Well, I go back to the hotel and I get a call from this guy saying, "We can meet tomorrow at such and such a time at the church." I said, "I'll be there at noon tomorrow." Five minutes later I get a call from the lobby of the hotel saying, "Mr. Sloan, come downstairs now. This is Father so-and-so." I go downstairs, we sat down—not at a bar, just in the lobby—and he said, "Take this card and copy down the number on something you have, but don't put my name with it. Just copy down the number and rip up the card and throw it away. If you have it on your person when you're stopped—and you will be stopped by the authorities—it could be dangerous for you." I did, and he proceeded to tell me what life was like for people there in Guatemala and what was going on with them. Indigenous people are suffering with a hostile government that tries to control them, and dealing with a country like America, which is responsible for a lot of what's going on in the place. On one of those assignments I was supposed to go to, I was in Guatemala, a high Catholic official was supposed to give an outdoor mass, and I got a call saying to go to Nicaragua instead. **You were supposed to go to where originally?** I was supposed to

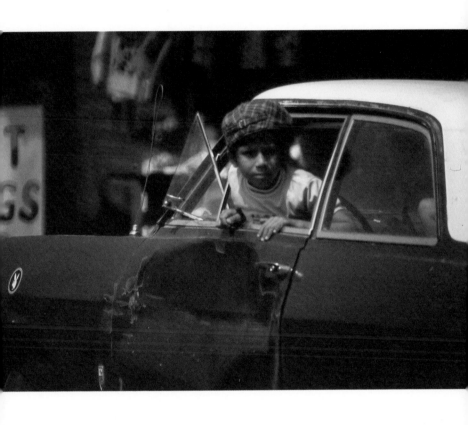

go to one country and I was told to go to Nicaragua instead to meet up with a reporter. And it's a good thing I didn't go, because I didn't go to the country where this archbishop was giving mass, and he was shot and killed. Had I been there, I would have been up close and trying to get pictures.

FATHER FIGURE

This man was an elder in a Muslim community in Los Angeles. I just happened upon him one day. I was driving. I had become aware of this community, and I wanted to go out and take some pictures. I saw him with his grandson. **So you just drove around looking for this community?** I was just out riding one day to get to know the people who live in other neighborhoods. **Was this a random encounter?** It was. **Okay.** It wasn't on assignment. This picture came after one with his grandson, because he was a wise old man, father figure, authority figure. Oftentimes we don't see Black men in that light. **Do you think you like taking photographs of fathers so much because of how much your father meant to you?** That, and because I remember I used to say, "I wish to be a wise old man someday." Because of the wise old men I'd met, the wise old men that even—you learn something from them even when they aren't trying to teach you anything. They were just telling stories and you could experience their wisdom. There was always something to learn if you paid close attention. I was so upset to realize how little I knew about this one actor, whose father fought in the Civil War, and he fought in World War I. He fought with the French, and some of these soldiers had Black commanders. There were all these connections.

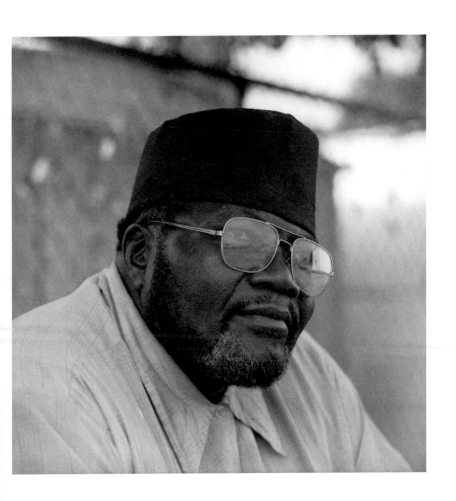

DIFF'RENT STROKES

You know, one thing I remember about Gary Coleman was the tragic life he had. I don't know what he was like up close and personal. As I remember it, he and his brother were adopted into a white family, were they not? **On the show?** Seems like his real family sorta messed him over. **Wait, on the show?** No, I mean in real life, his family. Seems like he was always—I mean this was, you don't want to talk about the scandals in his life. He was an interesting kid.

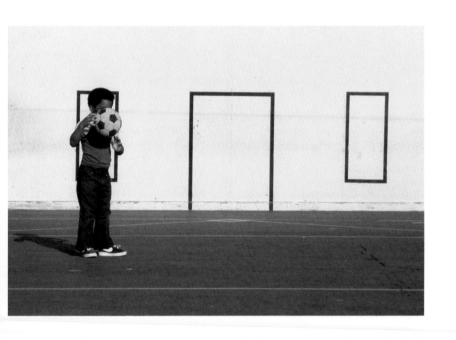

———

It's funny, he left the country a felon, went to Cuba, and from Cuba he went to—I think someplace in the Middle East, then he came back to Paris, and then he moved to LA and started a business on Sunset and La Cienega, Sunset Boulevard and La Cienega, selling pants. And later he ran for Congress on the Republican ticket in Orange County. Which [*laughs*] was puzzling to everybody, but when he came back he was a free man, no longer hounded by the police or the FBI, no longer wanted. **What was his campaign like?** Running for office? I don't think there was much of a campaign. I never covered any rallies that he had. I'm not sure he had any rallies, especially running as a Republican. He was just on the ticket. **What did Republicans think of him?** I don't think they gave him a thought. I don't think he expected to be taken seriously; it was just his way of saying, *I'm a real American. I believe in the system. I wanna be as ordinary as I can.* Black people just thought, He's gone stone crazy. He's joined the party of Reagan or George Bush. He was trying to fit in, but the only thing to fit were the pants. As far as the public was concerned, or as far as I was concerned.

PRETTY BABY

The image from the Philadelphia story. About a neighborhood destroyed by crack cocaine. **What about this particular picture?** Just a pretty baby. This is just a little girl on her front steps.

BUFFALO SOLDIERS

———

Black ski club in Utah. This was quite an awakening. I never knew so many people—Blacks—were interested in skiing. But, again, I remember they made a movie about a Black bobsledding team from Jamaica. It was a comedy; it was a joke; it was just something Black people weren't supposed to be able to do. That team didn't win an Olympic gold medal. But you realize you don't see yourself doing certain things because they're not associated with who you think you are, so nobody ever told you that the first forest rangers were the Buffalo Soldiers who fought in Jamaica or Cuba or wherever and they came back to the States and they became the first forest rangers. Which made it necessary for them to know how to ski.

SAMMY DAVIS JR. WAS VERY INTERESTED
IN PHOTOGRAPHY

———

If I didn't know any better, I would think the Black woman is Sammy Davis Jr.'s wife. **Altovise Davis?** Yep, the one in the center in the back. **Well, there's not more than one Black woman in the picture.** I know that. **Did you encounter Sammy Davis Jr. much?** I, uh, Sammy Davis Jr. was very approachable, and I reached a point where actually, in knowing him, if I called him up, he often responded, "Yeah, come on by." Thinking back, it seems we could have become good friends. He liked to talk, and he was also interested in photography. **Where'd you meet him?** I really don't know. It's funny: I guess I was doing a story about something he was involved in and we met. There was a guy that worked for one of the Black newspapers, and I got the impression he was sorta jealous at the access I had to Sammy, and I don't remember there being that many times when we sat down and talked, but I know Sammy Davis was very interested in photography. Especially when he discovered I was using Leica cameras. He wanted the best of everything, and he knew that the Leica was the best camera made. And this guy at the Black newspaper said, "Sammy buy you that Leica? I know he likes guys too." And I said, "If that's true, fine. He hasn't asked me to sleep with him or anything."

FOCUS

What's going on here? Well, in retrospect, this picture sort of captures a part of Kareem that no image of him doing a block or a sky hook could compete with. This concentration that—just being in the moment. His power of concentration, letting nothing interfere. And the thing about it, you're looking at a person who can succeed no matter what he does because he has this ability to focus and to block out anything else. His success as a writer, a historian, an actor or whatever, or a follower, trainer in kung fu and all that with Bruce Lee teaching him. His success has to do with his power of concentration, being in the moment: this is what we're doing now.

FROM A HIGHER POSITION

This says everything and it says nothing. **How'd you take that?** From a higher position. **Okay.** Carter boycotted the Olympics because of politics. The two guys with their fists raised at the '68 Olympics in Mexico were sort of forgiven. But there was one guy from Australia who was in solidarity with the two Black athletes, and he was ostracized by the Australian government, and the only two people who showed up to his funeral from the Olympics, who were pallbearers, were the two Black athletes. So there's a story behind the crowd, is what I'm saying. The Olympics has always been about politics. Even though Jimmy Carter took us out of the Olympics to punish Russia, but really he was punishing people who'd worked hard to make it to the Olympics, but then for political reasons we dropped out. And he ruined the lives of a number of people, and I suspect that, in retrospect, he was ashamed he did that. Because what is the point of saying, *It's not about politics*, when it's always us against them, or us against the world?

HARRISON FORD

———

I remember this being just an enjoyable assignment. This guy was a regular person, brought up in Chicago. He went and put on some music, and it was one of the most popular a capella groups of the time, and we were just sitting around there singing, doo-wopping together. This was in the Hollywood Hills, in a place that looked like he'd built it himself. Later, when he was more successful, I would see him in Brentwood at the coffee shop on Sunset. We would nod to each other. Sometimes I'd sit down with him; he'd invite me to sit down.

EVIDENCE OF THINGS NOT SEEN

———

This is Hugh Hefner looking through his volumes of *Playboy* magazine. **Where?** At the Playboy Mansion in Brentwood. **What was he like?** Nice person, hospitable, if you got inside the compound, if you were invited, you were "Have a good time." **Didn't James Baldwin publish a lot of his essays in *Playboy*?** Baldwin did work for *Playboy*. The book he wrote about the twenty young men that got killed in the South. **Atlanta?** Yeah. The editor of that story talked about how poorly written it was, this, that, and the other, how much they had to do to fix it up, how he was late for deadlines because he was always drunk. And I started feeling differently about my friend. **Didn't you tell him off or something?** I just remember saying, "I find it hard to believe that you had to do that much to salvage the story you hired James Baldwin to do," and even if it was that bad, I mean, Baldwin had accomplished more in the first two years of his career than this guy accomplished in his entire life.

AL THOMAS

———

How long did Al live in Rome? On the top of that apartment building? When he got out of the army, he was going to study voice in Germany, and he said he lived there, I thought a couple of years, and he realized Germany was not a place he wanted to be. He said there were opportunities to study voice. A lot of Blacks interested in opera got their chance after the Second World War because so many people who had fought in the war and who were interested in being in the opera had died. So you had this influx of Blacks who were interested in opera, so a lot of them got their chance to study and what have you. He was in Germany to do that long enough. But he discovered Italy and he said this was where he planned to spend his life. I don't even know if he went home that much, back to the States. He was a great storyteller.

THE QUIET HISTORY OF BLACK WOMEN IN PARIS

———

I was thinking about what I like about this picture, and it reminds me of when you took me to meet Barbara Chase-Riboud in Paris, and her apartment being so elegant. And then it also reminds me of *Diva*, and the Black opera singer in Luxembourg Gardens. Just this quiet history of Black women in Paris. That would be a wonderful film to do. **What?** Different women, different ages, different nationalities. Black women in one place but from different places.

———

That's sitting in a restaurant in Paris, I remember. At the time, she was getting a great deal of, as I remember, controversy about her book about the slave ship, or the movie being made, *Amistad*. That Spielberg was directing. And I asked her what was going on, and she said, "It's just some nonsense." Apparently there were scenes or characters created that appeared in the movie that she had actually created in her book about the *Amistad*. And, uh, there was a lot of back-and-forth, accusations being made about taking someone else's material and what have you. She's a very shrewd lady. I remember Dell Pryor met her when she came to Detroit once. Dell asked her, "Do you know Lester Sloan?" And she said, "He and his daughter come to Paris often and come and see me." [*Both laugh.*] **That's nice.** She was married to a famous photographer, Marc Riboud. Dell was saying she knew all these directors and photographers but none of them ever photographed her. **That was mentioned in a book about her.** There you have it. **But that was her ex-husband.** He was in Magnum, I think.

SYLVIA BRAVERMAN

———

I was feeling sad that I wasn't with Sylvia when she had gotten sick and she was dying. The last time I spoke to her, she was sort of in and out of the moment. Every time I look around, I come across more pictures of her, and I realize how her life tells the story of a person who left America, went to Europe in search of something. She was an illustrator for magazines and what have you. And that sort of worked into her becoming a fine artist, and you see the changes in looking at her sketches—just in her work you can see the artist or the painter emerging, the use of color in the images she created. Of people. They were much like what she did for these fashion magazines, sketches of this design and that design, and then she fleshed them out, the personality of the person started to emerge, the garment became secondary. It was the first time—except when shooting family members—that I've seen a story go from one point to another, in film or in single images. Individual images. And that's really—that's what it is. **Is there a correlation between her trajectory as an artist and your trajectory as a photographer?** I guess this is something you can see when you look back as opposed to looking forward, you can't see the whole story until you get to that point, but when you start going back and looking at different bits and pieces. You can see some sort of growth reflected in your work. **So you become a better artist when you are more familiar with your subject?** The subject is always—the work is always a place, a person—and those are made up of thousands of little moments. **A good single still photograph feels like many photos in one.** There are a few photographs I look at and I say, "God, I love that picture." And it's not so much who it is or where it is; it's just something that's familiar and special and you just recognize it.

———

I always got a kick out of photographing an artist's studio. Especially when you see things like: this is all part of his palette, where he got the different paints, cleaned his brushes or whatever, and that's almost as interesting a piece of art as the painting that resulted from these splotches of paint over here. **This is the guy, Jeffrey Hessing, who painted *Jimmy's Table*?** This is the guy who I met who painted *Jimmy's Table*. But Luther Van, the artist I met in Savannah, when he died, people were cleaning out his house and throwing away palettes, cans of paint he had, which I photographed, and they made some striking images. **He was one of the good friends you made while you were teaching in Savannah?** Luther, yeah, we got to be good friends. I can't say we were best friends, but we—he was just an amazing guy. He was curious about the world, but he traveled through books; he never left the country. I got the impression he didn't like flying or didn't trust flying. He was just a fascinating person, only person I ever knew that had a library in his bathroom. Luther had a wall of books in his bathroom. When he wasn't painting, he was reading. **So you saw *Jimmy's Table* being painted?** I was there when he painted—well, actually, he was painting it, or he had just finished it. Before I left, he gave me a poster.

BALDWIN'S BED

So you say this was the guest room? That's what I took it to be.
I mean, it's very simple. Actually, it's almost too small to be a bed for
a tall person. **So how did you find yourself there?** I was sent. Didn't
know it at the time, but I was sent. **What do you mean?** Because
I went there, to the South of France, not in search of James Baldwin
but just in search of all these other great people who had lived there.
Gordon Parks had talked about that great painter—what's his name?
Chagall. "Where'd you get that?" "Oh, Marc gave it to me." "Marc
who?" "Chagall." [*Laughs.*] Sylvia Bravermen put me in touch with
a young painter who had painted Gordon's house. **Baldwin's?** Bald-
win's house, who put me in touch with Baldwin's brother's friend,
who was the real estate person handling the property, and she said,
"Would you like to see it?" And I said yes. And then she dropped
me off and said, "I'll be back in a few hours. I have things to do."
I suppose nobody believed me when I said I didn't go through any
papers. There were things that were clearly pertaining to awards
he'd received and all that; I didn't feel I had any business snooping
through. I just took pictures of the things that were there. Even that
was enough. You think about all the reasons people say he ran off to
France, that he had no business being a civil rights leader because of
this or that. He took everything that was meaningful to him with
him. You could see it in the pictures on the walls, in his living room.
There were letters from friends and what have you. It was all there.
What do you mean you were "sent"? Well, you get older some-
times and you realize things are not a coincidence. There are things
that you—you're on a path. And whether you know it or not, this
was what was supposed to happen. Sometimes good, sometimes bad,

but there was a reason for things happening the way they happened, I think. The decisions you make are sometimes very important if you have this in mind, that this is supposed to happen. You were supposed to meet this person, you were supposed to trip and fall here. It's not the falling that's important; it's the getting up and going on. Usually if you live your life that way, it may not always be pleasant or it may not always be what you want, but it's preordained.

AFTERWORD

———

It is a peculiar sensation, this double-consciousness, this sense of
always looking at one's self through the eyes of others, of mea-
suring one's soul by the tape of a world that looks on in amused
contempt and pity. One feels his two-ness, —an American, a
Negro; two souls, two thoughts, two unreconciled strivings; two
warring ideals in one dark body, whose dogged strength alone
keeps it from being torn asunder.

—W.E.B. DU BOIS

My career started when a friend and mentor, Ed Bailey, told me that
the CBS affiliate in Detroit was looking for a cameraman. He told me
to put on a suit and freshen up and go interview for the job. At the
time, I was sporting a beard and a pretty big Afro. When I showed up
for the interview, the chief photographer told me I must have made
a mistake; there was no job being offered there. A couple of weeks
later I saw Bailey, and he asked me, "When are you going for the
interview?" And I told him I had already been. He said, "With that
shit on your head? Shave and get a good haircut and put on a Robert
Hall suit and go back. The job is still open." When I went back,
the chief photographer wasn't there, and I ended up talking to the
director of the news department. He told me he didn't know about
that job, but there was an opening for an overnight news editor who
would listen to the police radio and go out for anything that sound-
ed like a story. I was hired. I got started at *Newsweek* at around the

same time by taking pictures of the 1967 uprising in Detroit. They couldn't get white photographers to go out under those conditions.

From the start, being Black had its drawbacks and its advantages. I had a good friend named Howard Bingham. He was close with Malcolm X and Muhammad Ali. He was Ali's personal photographer until Ali died. At one point, *Life* magazine took an interest in doing a story on the Black Panthers, and Eldridge Cleaver let it be known that the only person they would be comfortable doing the story with was Bingham, whom they called their riot specialist. When he started taking pictures for *Life* magazine, he called himself their "riot specialist." I asked if they called him that and he said no, that's what he called himself because that's what he was. For better or for worse.

Eventually I moved to Los Angeles to work for *Newsweek* full time. That was around when John Dotson became the bureau chief. From the very beginning he gave me reporting assignments, which was totally unusual for a newsmagazine. I didn't know anyone else who was taking photos and reporting. I can only assume that he had reason to believe in me. Most editors didn't want to hear what I had to say, just asked for the negatives. From that point on, I became invested in the idea of reporting on the story I was photographing. Otherwise, the story can be distorted. What you've captured can be used to further some other narrative.

One story Dotson asked me to report on was about the Loud family. Elizabeth Peer, at the time a senior writer in New York, had ordered it. Bill and Pat Loud lived in Santa Barbara, and they were subjects in one of the first reality shows about a "typical" California family. I went there and listened. I looked around and picked up an ashtray: on the bottom, the price tag was still there. It looked like a set designer had created the rooms. Everything was too perfect: their clothes, the conversation, the setting. It was too much like watching *The Adventures of Ozzie and Harriet*. Peer was upset that I, a photog-

rapher, had been given a reporting assignment. She was vocal about her feelings. But once she saw the reporting, she was pleased with it, and made a point of letting both John and me know she was impressed. If you're a good reporter and you take pictures, too, you can come up with something that is quite interesting—it sort of flows. Oftentimes, photographers on a story are the best reporters. But for the most part, I wasn't asked to report on the stories I covered.

In 1975 I applied for a Nieman Fellowship. Karl Fleming was the former bureau chief of the Los Angeles bureau; he had retired, but we remained friends. When I told him about the interview for the fellowship, and that I had made the final cut, he said, "I'm going to tell you something about white people." He said, "They like color, but they like color under control." He said, "Cut your Afro down and take off that turquoise ring that you bought at the Navajo reservation. But most of all, beware of the question couched in a compliment. Just remember that." During my interview one of the judges said, "A photographer interested in writing and film: Would you like to be the next Gordon Parks?" A light went off in my head, and I replied, "Yes, Gordon Parks is one of my heroes. But if I was interested in being a filmmaker, I wouldn't have applied for a Neiman; I would have gone to the American Film Institute in California." A couple of weeks later, I received my letter of acceptance. You have to walk this fine line. You have to both fulfill and transcend their expectations for you.

While I was hoping to work in Europe, preferably France, I decided to take German classes because at least I was familiar with it from college. I saw a story about how the East German government was thinking of having a more positive relationship with West Germany. What was going on in Eastern Europe had repercussions everywhere. Call it a social pandemic: it affected all parts of the world. I talked to one of the editors in the photo department, who told me

to go right away. I arrived in Berlin the morning of the ninth of November 1989, and the wall came down at the stroke of midnight.

I met up with Pat Cole, another African American journalist who was in Germany on a fellowship, and we heard about a demonstration in Leipzig. When we arrived, we encountered a crowd marching around the headquarters of the East German secret police, the Stasi building. They were singing "We Shall Overcome." When they spotted us, two Black Americans, a few of them said, "Join us! We learned from you." I remember telling this story to Karl Fleming years later, and he responded, "If that's the case, we missed the story." Even in a democracy with its free press, we have our own walls. It doesn't take a photographer to see that.

I was in Germany a couple of years before the wall came down, staying with a German couple. One evening at dinner they said they had a surprise for me: they had two tickets for a concert in East Berlin, and they couldn't go. It was a packed house, and everyone seemed to be in tune with the gospel-singing blues singer dressed in a red jumpsuit, with a gold lamé cape. The 450-pound artist wiped his brow with a handkerchief and a murmur erupted from the crowd. When he sang the words "I was born by the river in a little tent," the packed audience inhaled, joined in as if on cue. Later that night I was told that Solomon Burke had been asked not to sing that Sam Cooke classic "A Change Is Gonna Come," but he did it anyway. Moments like that say so much about what was happening in Germany. But Americans, or specifically white editors in America, seemed uninterested in or oblivious to the correlation between what was happening to East Germans and what was happening to Blacks in their own country. The Germans kept trying to tell us. That was the real story.

My mother was the storyteller in our family. The tradition goes back to our ancestors. In Africa the old men used to sit under the baobab tree, talking about the elders, talking about the traditions

of the tribe. A more modern-day version of that is the barbershop or the beauty parlor. Growing up, I remember seeing men sitting around a bonfire drinking and talking. It's as old as mankind. When we sit down and gather, we're telling stories. When we go to church, we're telling stories. When we're singing or acting out, we're telling stories.

The story is always the most important thing. I worked for a magazine that really wanted me to be a photographer. When I got an opportunity to do both, I did. But so many of the pictures I took ran without my getting the chance to tell the real story. Or the whole story. Or the understory. So that's what we've included here.

—LESTER SLOAN

TITLES

While the exact date and location were available for some of these images, the information provided for others is approximate.

Dr. Seuss, San Diego, 1980s
Musée Picasso, Paris, 2001
Joseph and Argusta Sloan, Malibu, California, 1980s
Children, Philadelphia, 1989
Kids playing basketball, Detroit, 1981
Mikhail Baryshnikov and fellow dancer, Los Angeles, 1979
Young boy swimming, Bahamas, 1973
Marsha Hunt, Los Angeles, 1979
David Hockney and his mother, Los Angeles, 1984
George H. W. Bush, Ralph Abernathy, and Ronald Reagan, Detroit, 1980
Carroll O'Connor, Los Angeles, 1978
Joan Baez, Los Angeles, 1970s
Wall or window, Detroit, 2018
Pope John Paul II, Los Angeles, 1979
Nastassja Kinski, Los Angeles, 1981
Ken Moss, San Francisco, 1973
Man in profile, Frankfurt, 1970s
Brandenburg Gate, Berlin, 1989
Afro-German woman, Berlin, 1970s
David Geffen, Los Angeles, 1990s
Young boy, Detroit, 1980s

Young men, Los Angeles, 1980s

Barber and sons, Pasadena, California, 1989

Marvin Gaye, Los Angeles, 1973

Bobby Jackson, Los Angeles, 1973

Tippi Hedren and Noel Marshall, Los Angeles, 1981

Alfred Hitchcock and others, Los Angeles, 1981

Joel Fluellen, Los Angeles, 1980s

Beah Richards, Los Angeles, 1990

Richard Pryor, Baton Rouge, 1982

Spike Lee, on the set of *Get on the Bus*, 1996

Uprising, Los Angeles, 1992

Hawaii, 1977

Navajo land, Arizona, 1985

Navajo land, Arizona, 1985

Ed Clark, Paris, 1990s

Julia and Helen Wright, Paris, 1992

George Whitman at Shakespeare and Company bookstore, Paris, 1994

Queen Elizabeth II and Ronald Reagan, Windsor Castle, Berkshire, UK, 1982

Aisha Sabatini Sloan, Lorraine Sabatini, Jessica Smith, Los Angeles, 1982

Street sign, Bahamas, 1973

Police raid, Los Angeles, 1987

Central jail, Los Angeles County, 1988

Frank Gehry's home, Santa Monica, California, 1980s

Frank Gehry at his home, Santa Monica, California, 1980s

Prince Charles and Lynden Pindling, Bahamas, 1973

Selma Burke, New Hope, Pennsylvania, 1990s

Sketch for the dime, New Hope, Pennsylvania, 1980s

Fishing, place unknown, 1970

John Voight, Los Angeles, 1981

Bette Midler, Los Angeles, 1980s

Magic Johnson, Los Angeles, 1994

Bruno Bettelheim, Los Angeles, 1980s

Paul Williams's family, Los Angeles, 1995

Young mother, Philadelphia, 1989

Florence Griffith Joyner, Los Angeles, 1984

Overhead water, Central Valley, California, 1990s

Food from the 'Hood, Los Angeles, 1995

Power grid, Palm Springs, California, 1978

Cancer clinic, Tijuana, Mexico, 1979

Young tailor, Tijuana, Mexico, 1979

US-Mexico border, San Diego, 1990s

US-Mexico border, San Diego, 1990s

Nancy Reagan, California, 1980s

Michael Jackson, Neverland Ranch, Los Olivos, California, 1981

Forest, Vermont, 1977

Plane window, Maui, 1977

Stevie Wonder, Los Angeles, 1977

Dionne Warwick, Los Angeles, 1990s

Huey P. Newton and Elisabeth Coleman, Oakland, California, 1980s

Bus stop, Bahamas, 1973

Church, Bahamas, 1973

Olympics Opening Ceremony, Sarajevo, Bosnia and Herzegovina, 1984

Nelson Mandela, Detroit, 1990

Uprising, Detroit, 1967

Police surveying a crime scene, Los Angeles, 1990s

Maxine Waters and Jesse Jackson, Los Angeles, 1992

Hotel, Cabo San Lucas, Mexico, 1990s

Lowriders Club, East Los Angeles, 1979

Nuns, Tijuana, Mexico, 1974

Beatrice Wood, Ojai, California, 1994

Zubin Mehta, Los Angeles, 1979

Keith Richards and Patti Hansen, Cabo San Lucas, Mexico, 1983

Laura Dern, Los Angeles, 1986

Anita Baker, Los Angeles, 1990s

John Singleton, Los Angeles, 1990

Lester Sloan, Venice, Italy, 1980

Captain Bill Pinkney, Detroit, 1992

Spencer Haywood, Venice, Italy, 1980

Sandra Day O'Connor, Phoenix, 1981

Ted Kennedy, Los Angeles, 1990s

Walter Mondale, Lake Jackson, Florida, 1983

Kid in car, Nicaragua, 1980

Muslim man, Los Angeles, 1990s

Gary Coleman, Los Angeles, 1980s

Eldridge Cleaver, Los Angeles, 1978

Little girl, Philadelphia, 1989

Black ski club, Park City, Utah, 1999

Basketball shoot, Los Angeles, 1980s

Kareem Abdul-Jabbar, Los Angeles, 1980s

Olympics, Los Angeles, 1984

Harrison Ford, Los Angeles, 1970s

Hugh Hefner, Los Angeles, 1986

Al Thomas, Rome, 1990s

Diners, Paris, 1990s

Barbara Chase-Riboud, Paris, 1992

Sylvia Braverman, Vence, France, 1990

Jeffrey Hessing's studio, Vence, France, 1990

James Baldwin's home, Saint-Paul de Vence, France, 1990

ACKNOWLEDGMENTS

———

From Lester: There are more people to thank than I can possibly mention here. Thank you to Kurtz Myers, who was there at the beginning, even before I got involved in journalism. You saw something in me and said, "Let's feed this curiosity," and you introduced me to Shakespeare and the symphony and got me onstage with Leontyne Price. Thank you to John Dotson, the bureau chief of *Newsweek* magazine in Los Angeles, whom I met while covering the Detroit uprising. You told me to go out there and try, and you gave me a chance to do things no one else would let me do; you were, above all, a dear friend. Thank you to Jimmy Colton for your support during and after *Newsweek*, and to Jim Kenney, who taught me about the politics of working for a large organization. Thank you to Rod Gander, chief of correspondents at *Newsweek*, who hired me: you were behind me from the get-go. Karl Fleming, you were an unexpected supporter, the most celebrated reporter we had at *Newsweek*. You told me how to read the intentions of people by how they ask questions. Thank you to J. Edward Bailey, a mentor and photographer who worked for Time Life. You sent me out, then sent me out to do it again if I didn't get it right; you also paid me accordingly.

Thank you to Gordon Parks—before and after I met you. You were the reason I considered photography as a possible career in the first place, and once we met, you were a supporter and a friend. Thank you to Adger Cowans, who made my friendship with Gordon possible: you drew my eye to photography as an art. Thank you to Deborah Willis, who once told me I was the next Gordon Parks; you never forget a compliment like that. Thank you to the Nieman Foundation for giving me an opportunity I had only dreamed about,

and that launched me into a new phase of my career. Thank you to Sylvester Monroe, Vern Smith, Dennis Hunt, Howard Bingham, Pat Cole, and Bruce Talamon. We shared this journey, and we were there for one another. Thank you to Ollie Harrington, a rebel who wasn't sorry about it, and such a great storyteller. You taught me how to listen. Thank you to my friend and former colleague at *Newsweek* Dewey Gram. Your stories of travel and living abroad stoked the fires of my imagination. Thank you to Garth Fagan, a living example of how to work and hold on to your dream until it comes true.

Thank you to Toni Ford for always thinking of me when you had new projects. Thank you to Dell Pryor for including me in the exhibitions at your galleries in Detroit and New York and for being a pioneer in your own right. Thank you to LaVetta Forbes, who hired me to take trips to some of the most beautiful places in the world.

Thank you to my mother, Argusta Sloan, the first storyteller in my life, and to my father, Joseph Sloan, a man of hidden histories: you were the keepers of the dreams. Thank you to my daughter Felicia. You were there when the journey started. You are my profile in courage, and you teach me how to be a winner. Thank you to my grandson, Jeremy Mulligan. Your honesty and the pointed revelations in your several books reveal the evolution possible in all of us. Thank you to my brother-in-law Paul Sabatini for being you. Thank you to Rodney MacDonald, who always encouraged me to have confidence that these stories should be told, for being a dreamer, and for moving through the world "just like in the movies." Thanks also to Rodney's mother. You said, "This is your chance. Don't worry about us. We'll always be here." And thank you to my wife, Lorraine Sabatini: none of this would have happened without you.

From Aisha: This book came about because Vivian Lee Croft was kind enough to introduce me to Amanda Uhle, on a whim. Thank you for picking me up at the airport, taking me to the museum, and opening up this world of possibility. So many thanks to Amanda. You said, "Pitch me that book" when I began telling you about my father's archives, and here we are—this book wouldn't exist without your adventurous sense of vision, your kindness, and your collaborative spirit. Erica Vital-Lazare, thank you for being such a generous and lyrical thinker, for conceiving of the series Of the Diaspora, and for inviting us to be part of it. Thank you to Alvaro Villanueva for your incredible instincts and patience in putting together the gorgeously designed interior of this book. And thank you to Sunra Thompson. Your stunning cover design makes this book into an art object. Thank you to the whole McSweeney's team. It means the world to us to have a tangible object in a world of fleeting images and photographs that exist only in clouds. Thank you to the incredible Jack Jones team, Kima Jones and Sin á Tes Souhaits, for bringing this project into the wider world. And thank you to my agent, PJ Mark. You go above and beyond; we are so lucky.

Thank you to the *Paris Review* for publishing "On Immolation" and "Crossing Goethe" (originally titled "On Hello"); to *Vanity Fair* for publishing "His Own Private Diaspora" (originally titled "Visiting the European Homes of James Baldwin, Barabara Chase-Riboud, Ed Clark, and More Black Expats"); and to *Gulf Coast* for publishing "Black Hollywood."

As always, thanks to Hannah Ensor for putting up with the constant background din of father-daughter conversation for so many months. Your delight at the prospect of this project ushered us on.

ABOUT THE AUTHORS

———

LESTER SLOAN is a writer and photographer living in Detroit. He began his photography career as cameraman/reporter for the CBS affiliate in Detroit, then worked as a staff photographer for *Newsweek* magazine for twenty-five years, documenting the 1967 uprising in Detroit, the fall of the Berlin Wall, the kidnapping of Patty Hearst, and the OJ Simpson trial. He has served as a contributor to *Emerge* magazine and NPR's "Weekend Edition." The recipient of a 1976 Nieman Fellowship at Harvard University, he was the on-set photographer for Spike Lee's film *Get on the Bus*. He is an avid collector of oral histories.

AISHA SABATINI SLOAN's writing about race and current events is often coupled with analysis of art, film, and pop culture. She earned an MA in Cultural Studies and Studio Art from NYU and an MFA in Creative Nonfiction from the University of Arizona. She is the author of the essay collections *The Fluency of Light: Coming of Age in a Theater of Black and White* and *Dreaming of Ramadi in Detroit*, and the forthcoming book-length essay *Borealis*. A 2020 recipient of the National Endowment for the Arts fellowship, she is an assistant professor of creative nonfiction at University of Michigan.